ZEN DOODLE
COLORING BOOK

Relax and Relieve Stress
with Adult Coloring Pages

Edited by
KRISTY CONLIN

NORTH LIGHT BOOKS
cincinnati, oh
createmixedmedia.com

introduction

some days I just need a break. A break from the stresses of everyday life. From the million little tasks and responsibilities that crowd my to-do list. A break from the world around me and its 24-hour news cycle. You know what I need? I need ME TIME. I'm betting you could use a little ME TIME, too. Am I right?

So I'm going to give us both permission to stop and smell the proverbial flowers. Put the bills away, turn off your phone and put the tablet away.

In your hands right now you have a tool that can help you relax and wash away the stress and lose yourself—for at least a little while and if only you'll let yourself go. Remember when you were a child and you got deeply, intensely focused on coloring in your coloring books? Well, that's what we have here—a coloring book for adults. This coloring book is built of some lovely zen doodle art, and the premise behind the art form is that drawing simple, repetitive patterns on paper can be calming and can unlock creativity. Coloring in these inspiring, fun and unique designs will surely help you relax and relieve stress. You'll clear your mind, you'll have fun and you might even have a pretty piece of art to frame when you're finished.

So grab some colored pencils, artist's markers, watercolor pencils or even watercolors. Find a nice quiet, comfortable spot, and ... color to your heart's content. Meditate, lose yourself, find yourself.

Enjoy the simple things.

~KRISTY

(A special thank you to the dozens of artists whose work graces these pages. They are each a valued part of our zen doodle community, through inclusion in *zentangle® untangled, The zentangle® untangled workbook, creative Tangle, zen Doodle: Tons of Tangles and zen Doodle: oodles of Doodles.* Pick up any of those books for more information on the artists as well as tutorials and tips.)

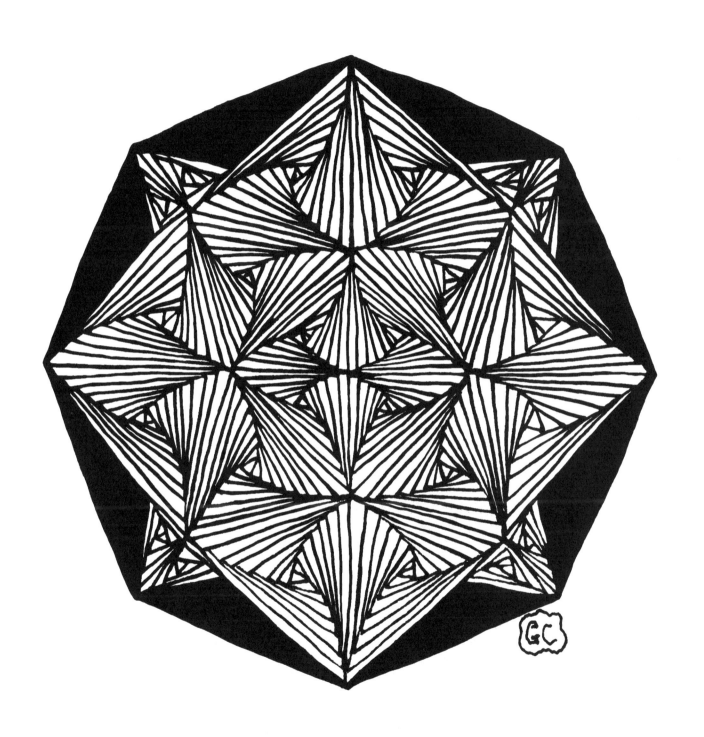

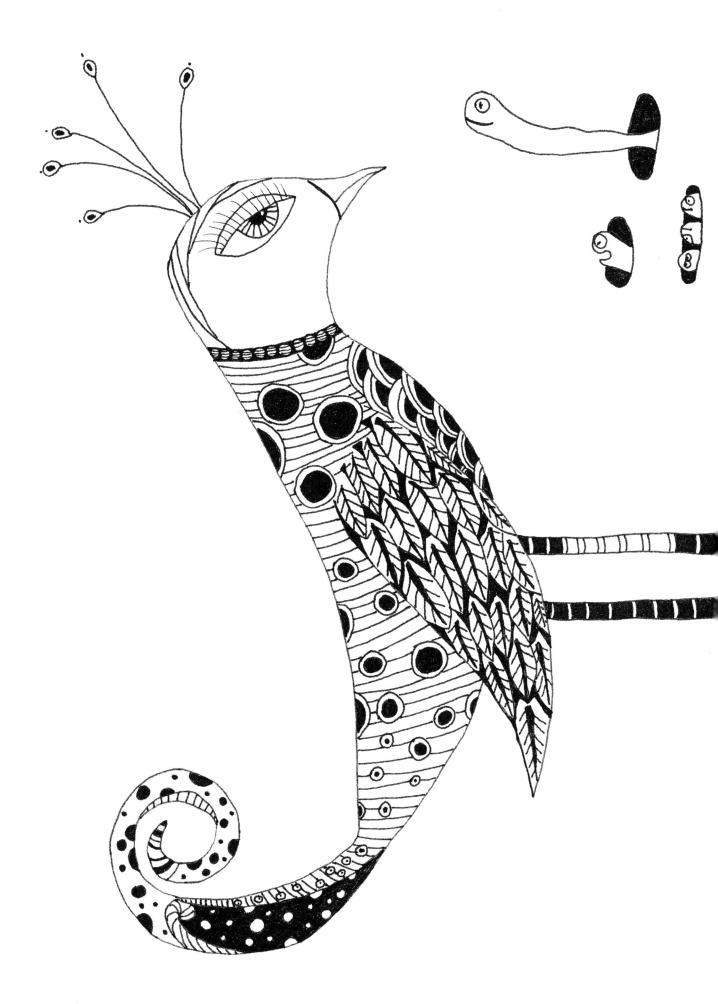

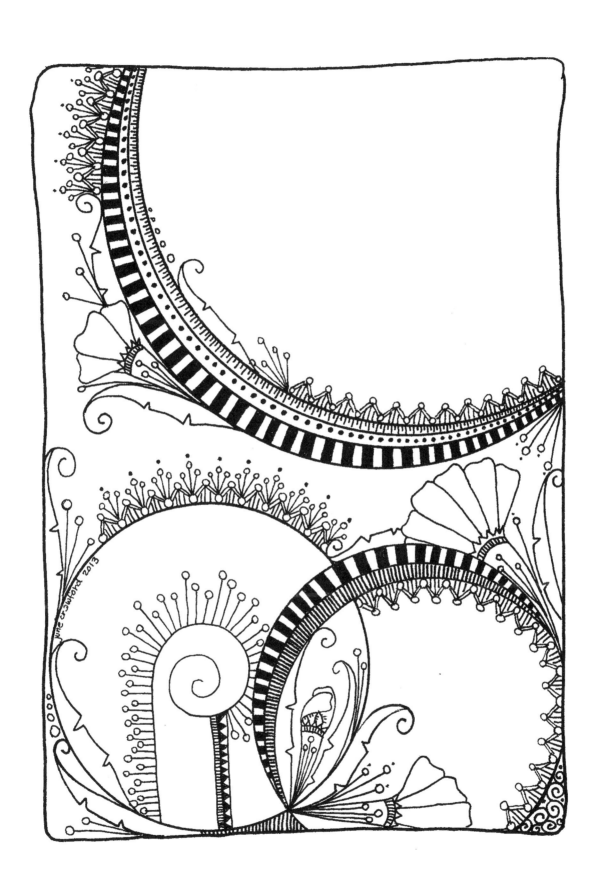

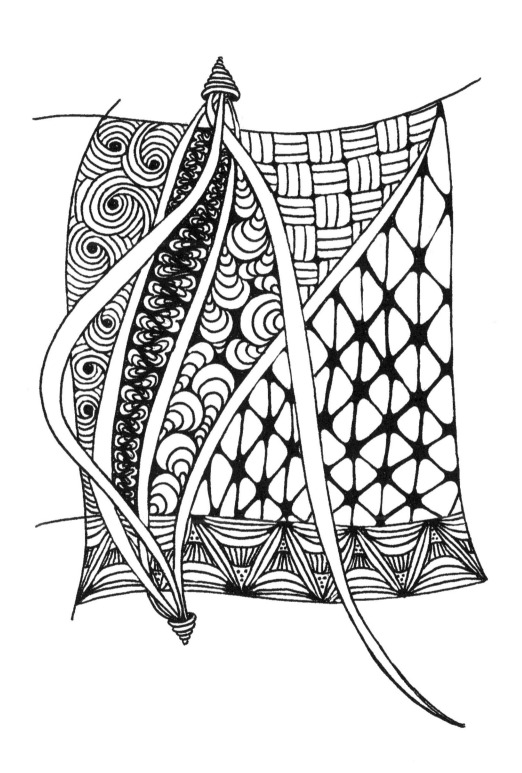

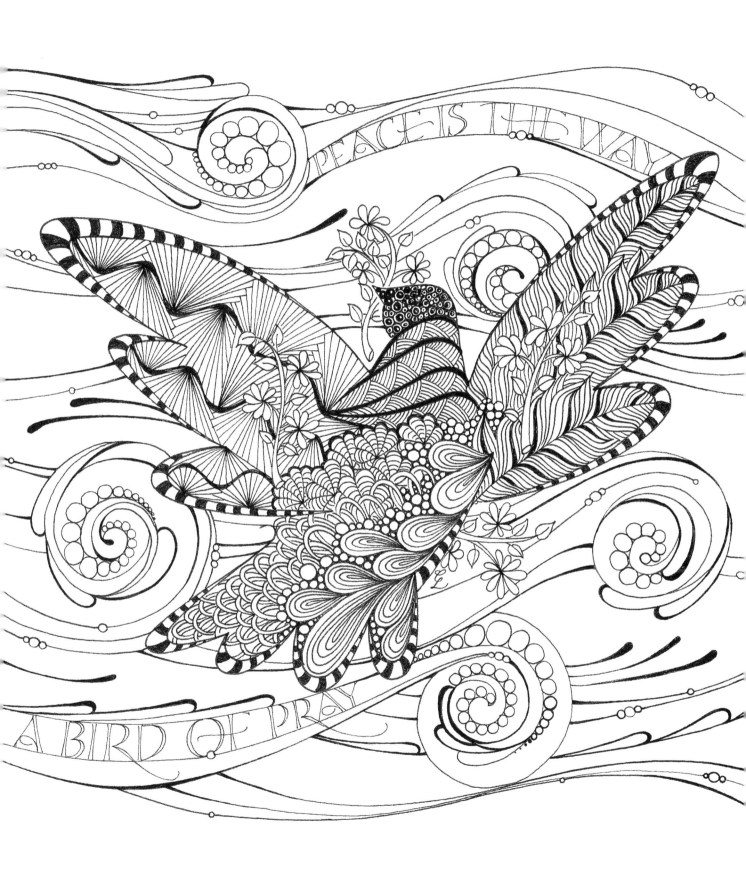

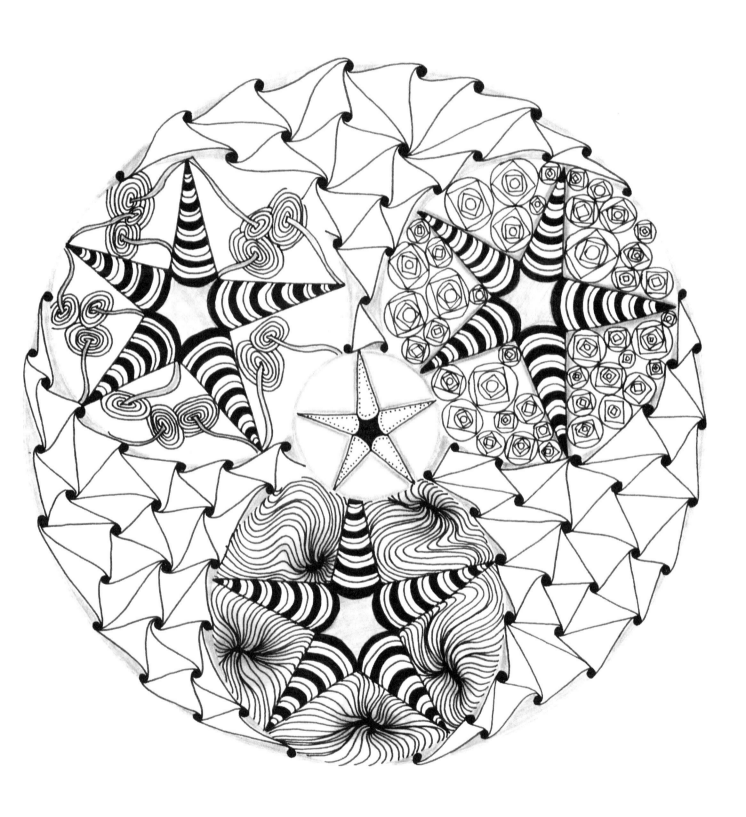

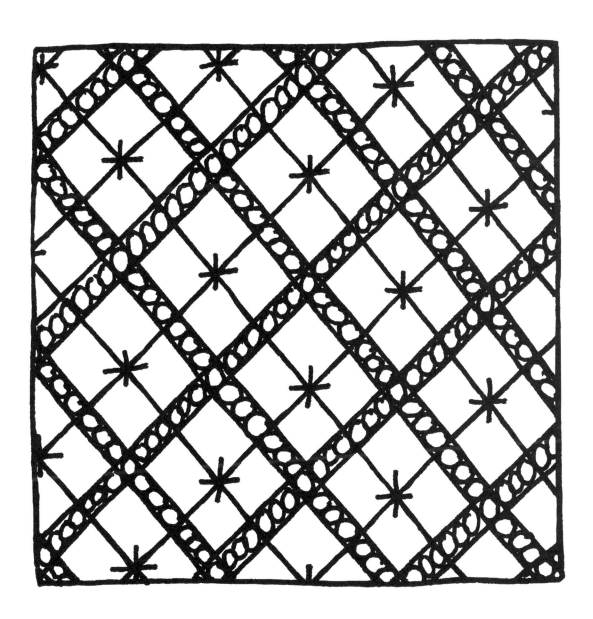

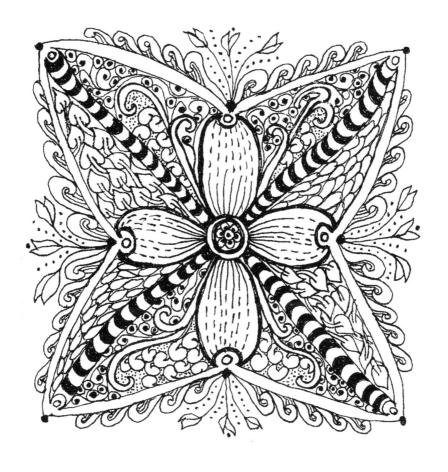

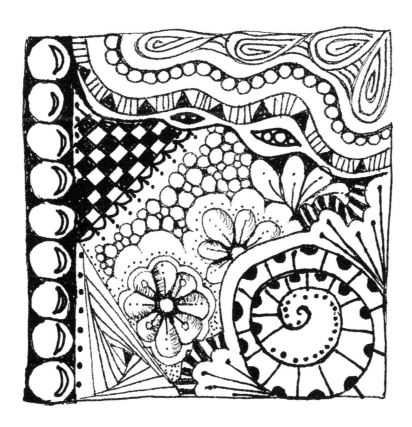

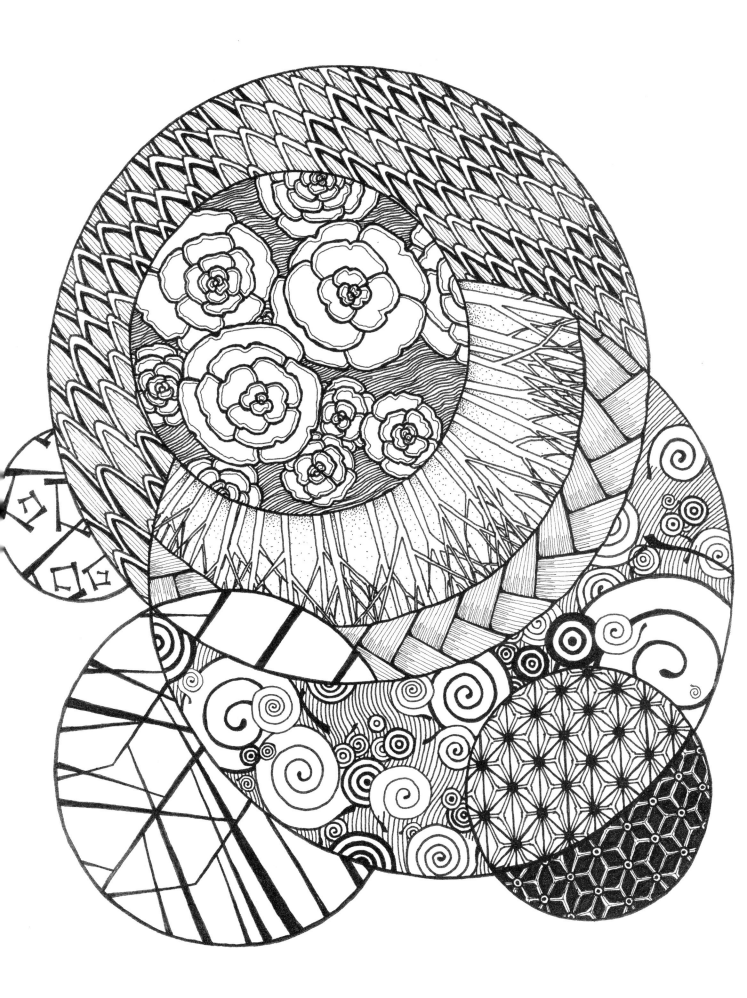

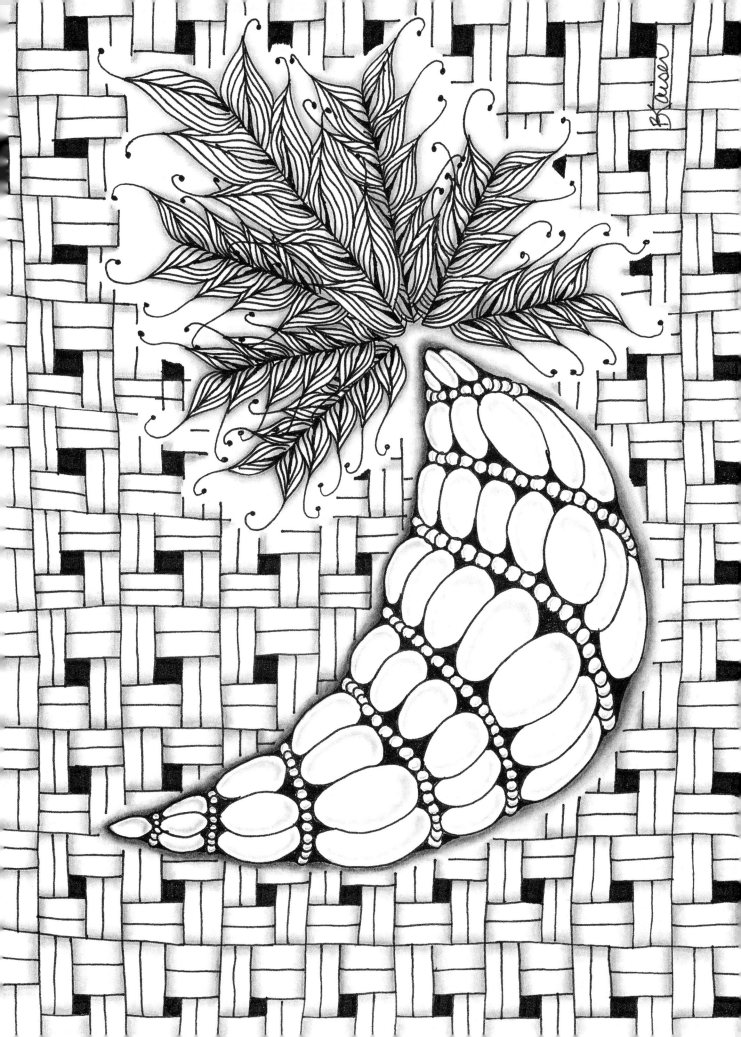

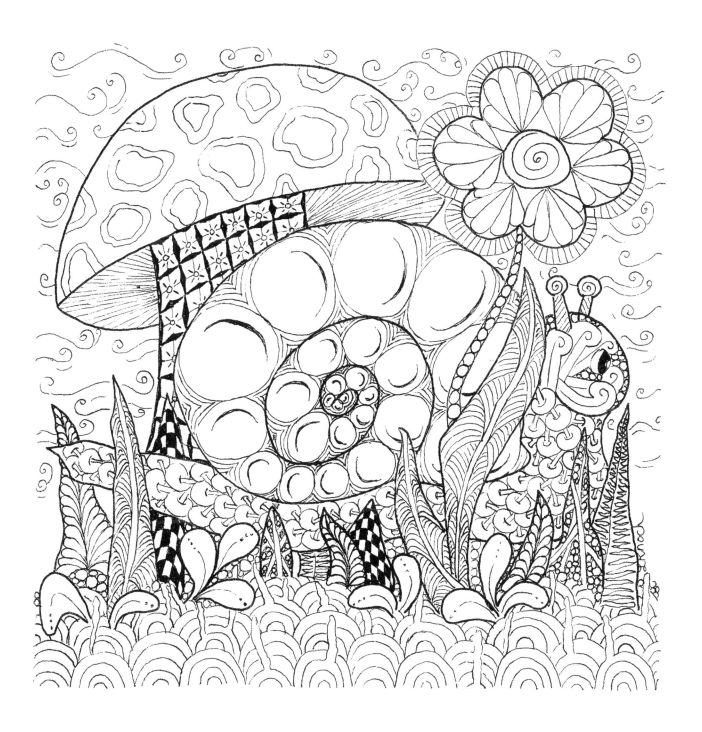

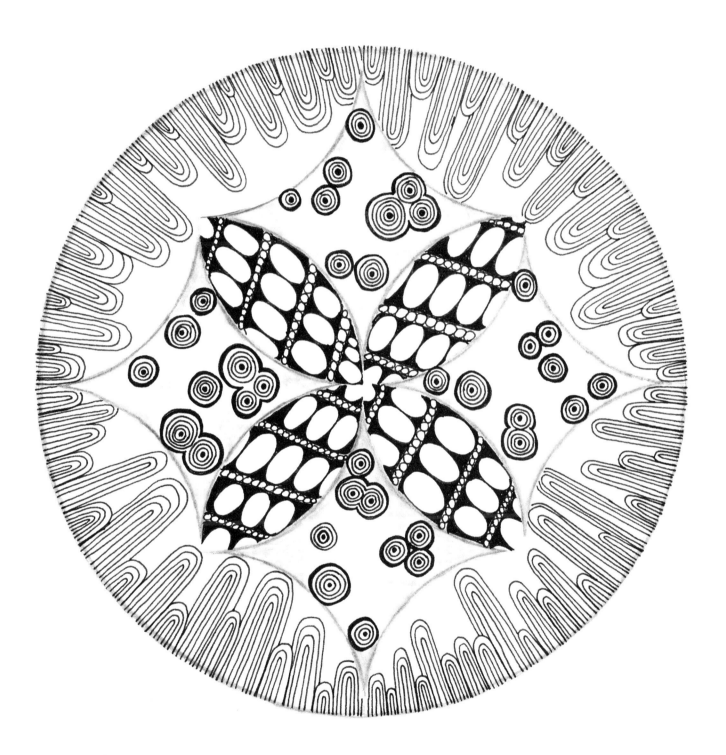

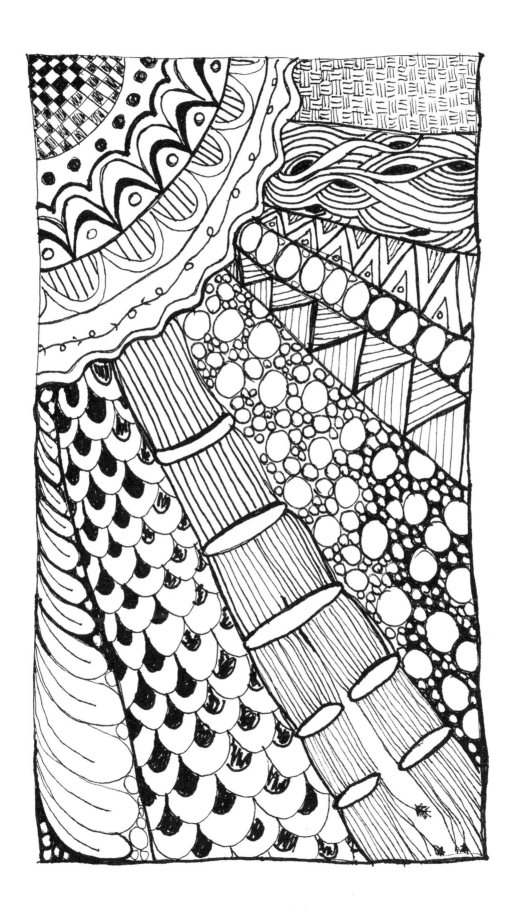

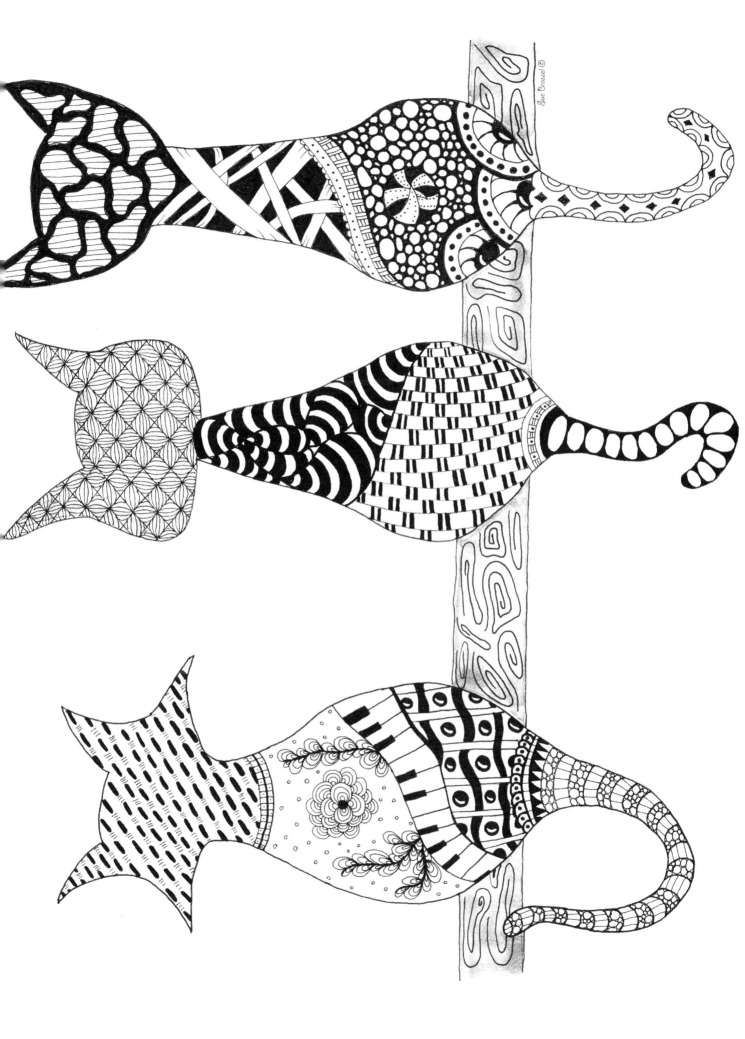

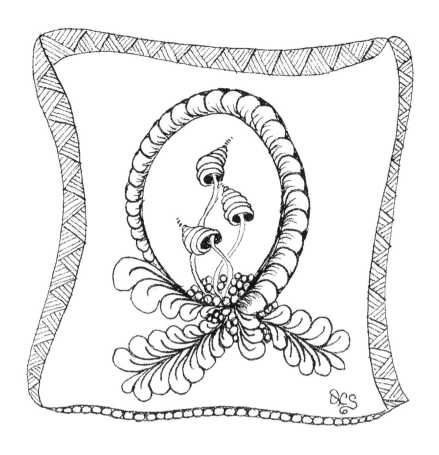

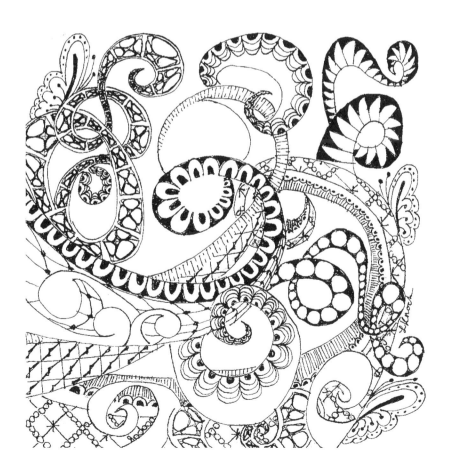

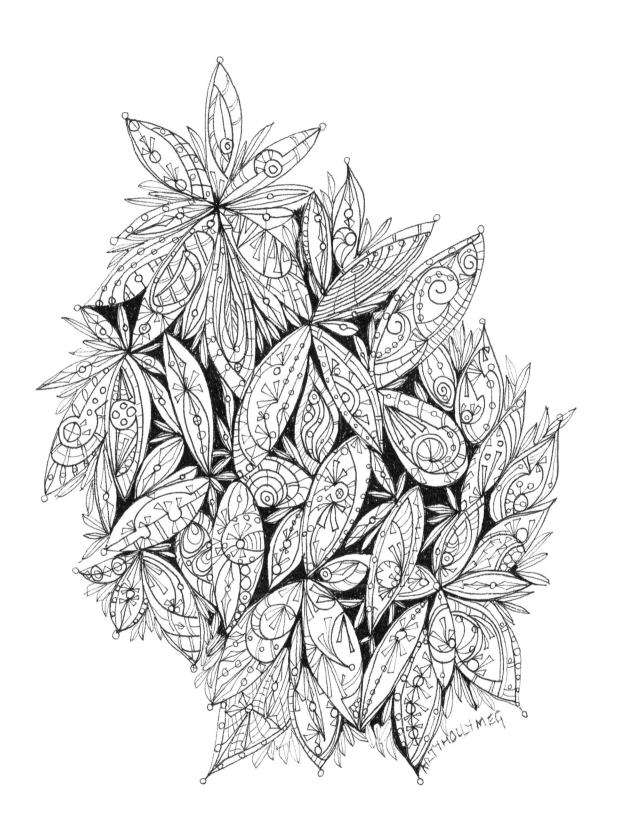

PREVIOUS PAGE:
Leaf study I
SALLY HARRISON
(FROM ZEN DOODLE: OODLES OF DOODLES)
staedtler pigment liners on cartridge paper

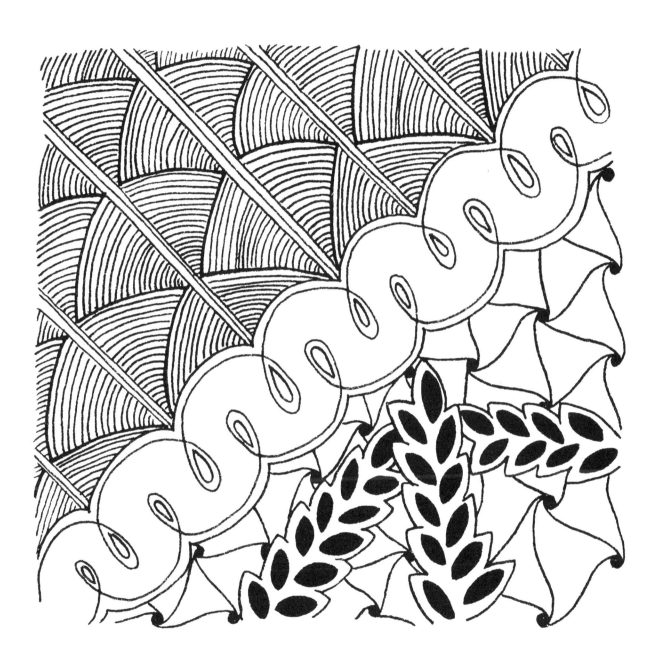

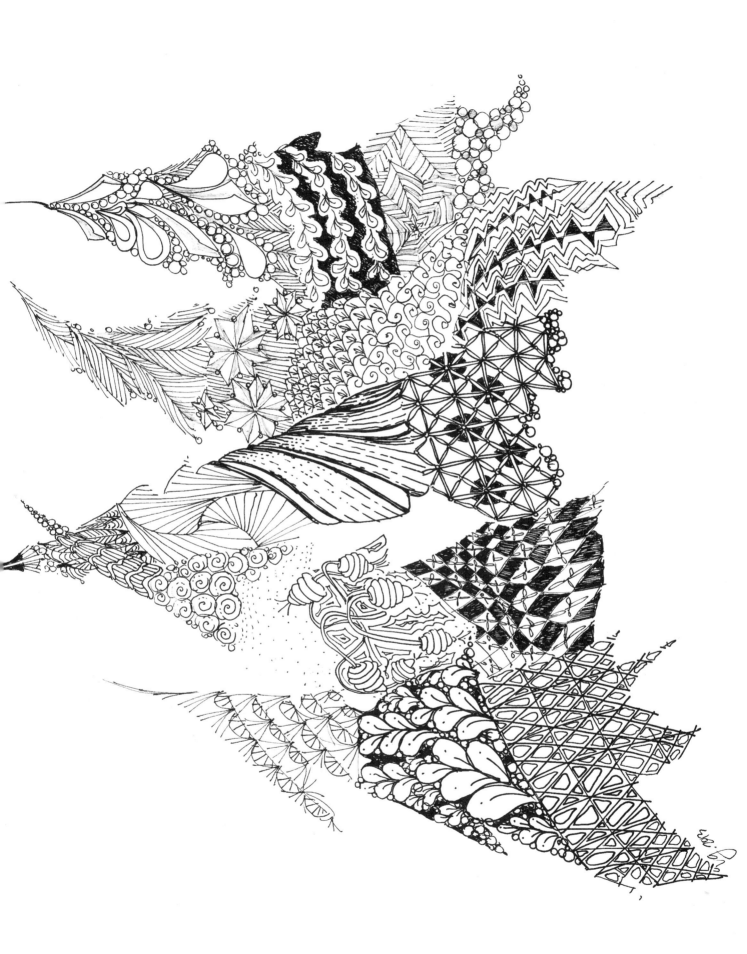

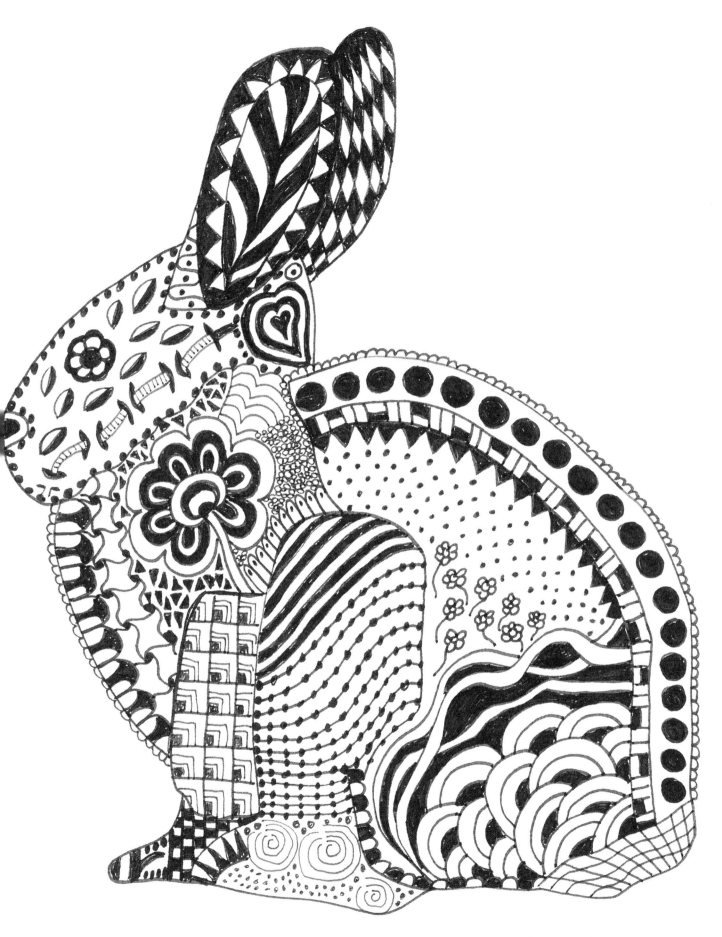

Barbara Simon Dunbain

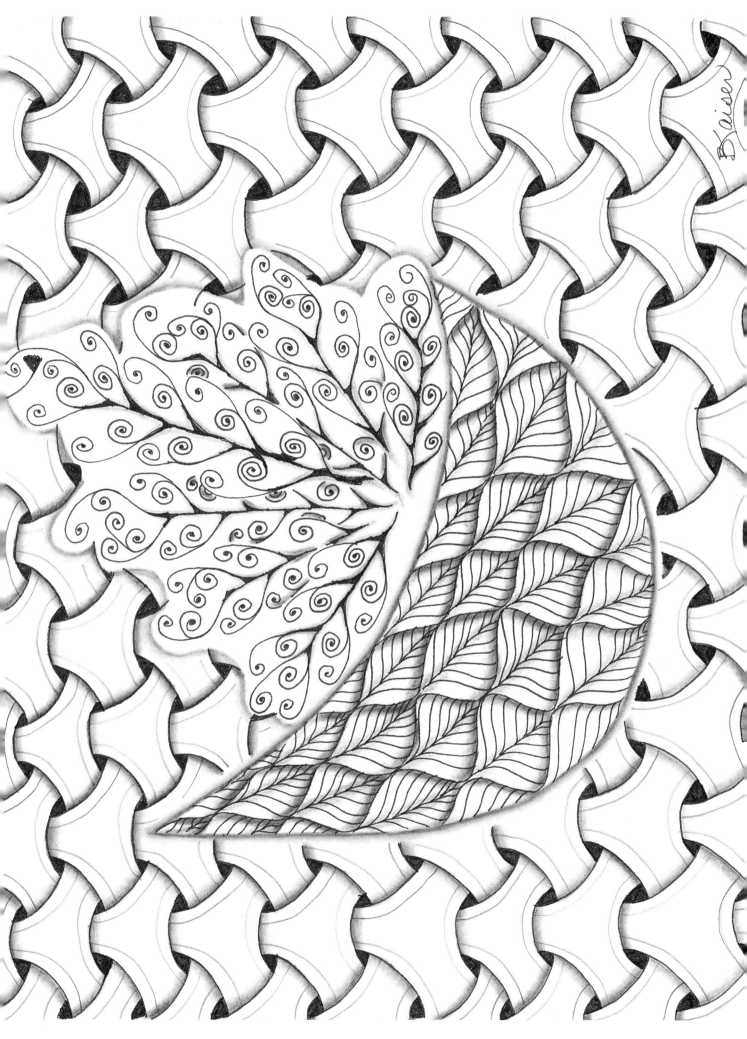

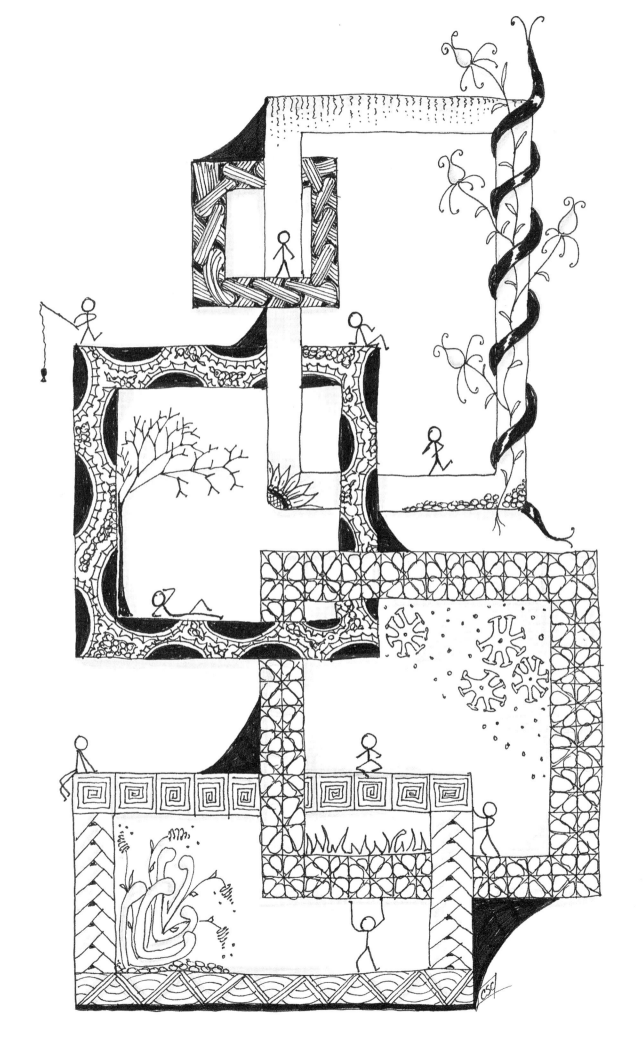

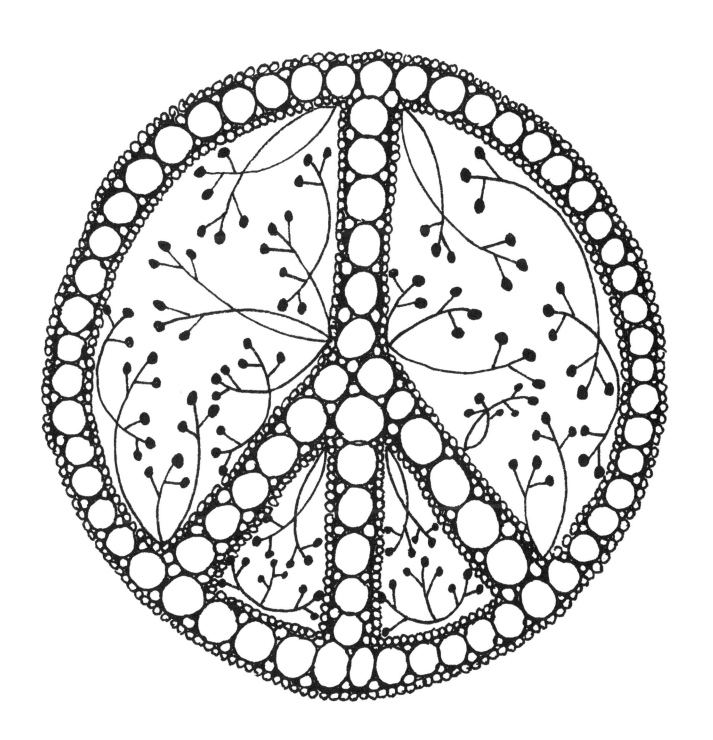

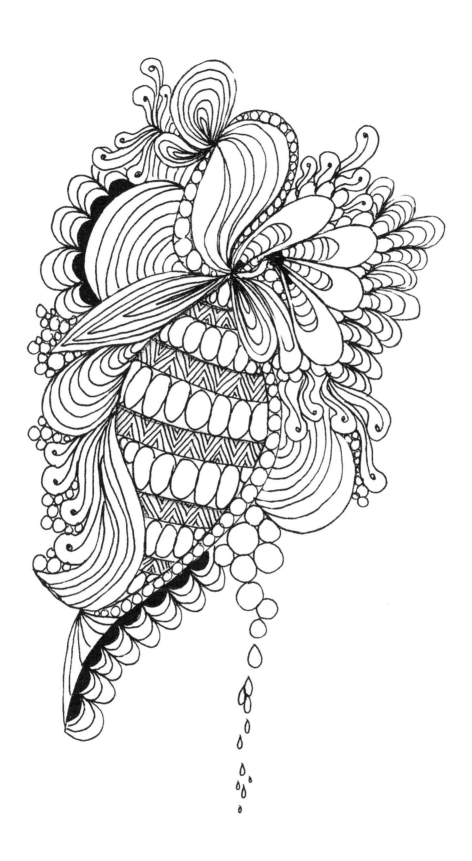

PREVIOUS PAGE:
untitled
DEBORAH A. PACÉ
(FROM ZEN DOODLE: OODLES OF DOODLES)
sakura pigma micron pens on paper

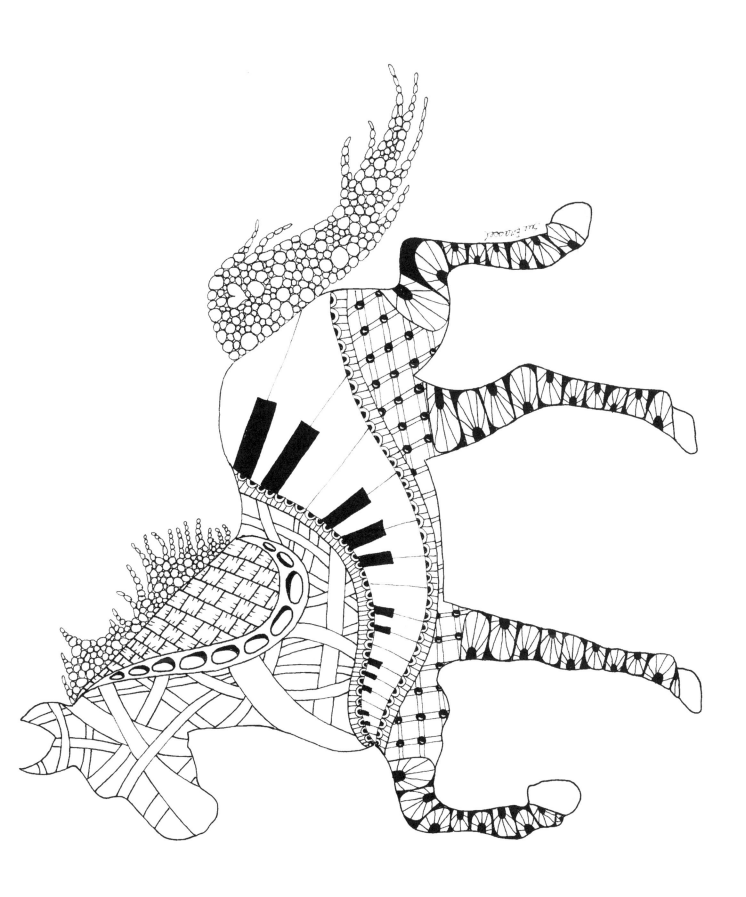

PREVIOUS PAGE:

cheval de cirque

SUE BRASSEL

(FROM ZEN DOODLE: TONS OF TANGLES)

sakura pigma micron pens and art markers on bristol paper

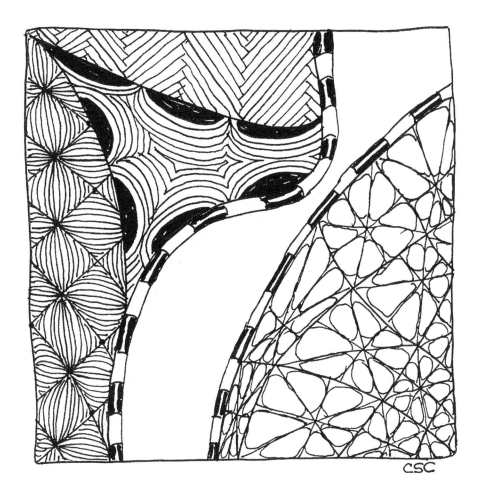

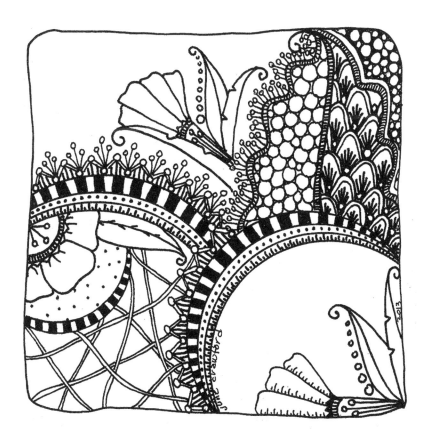

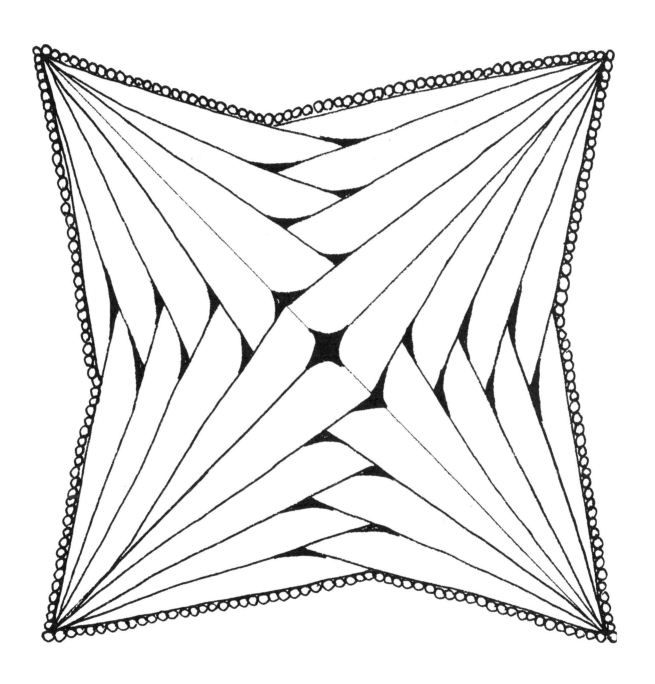

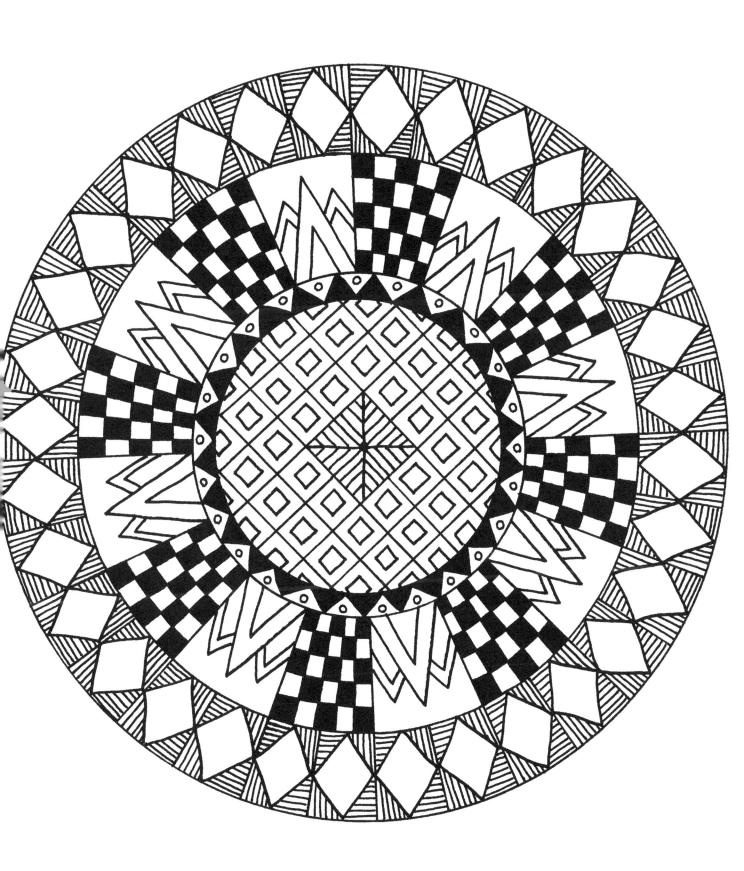

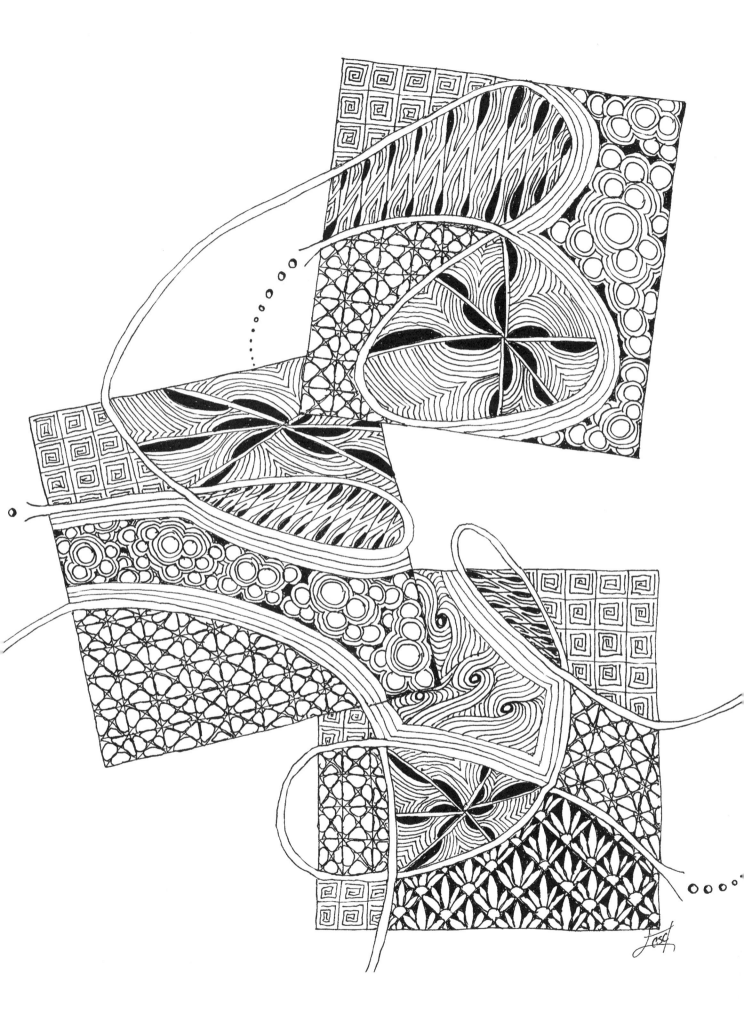

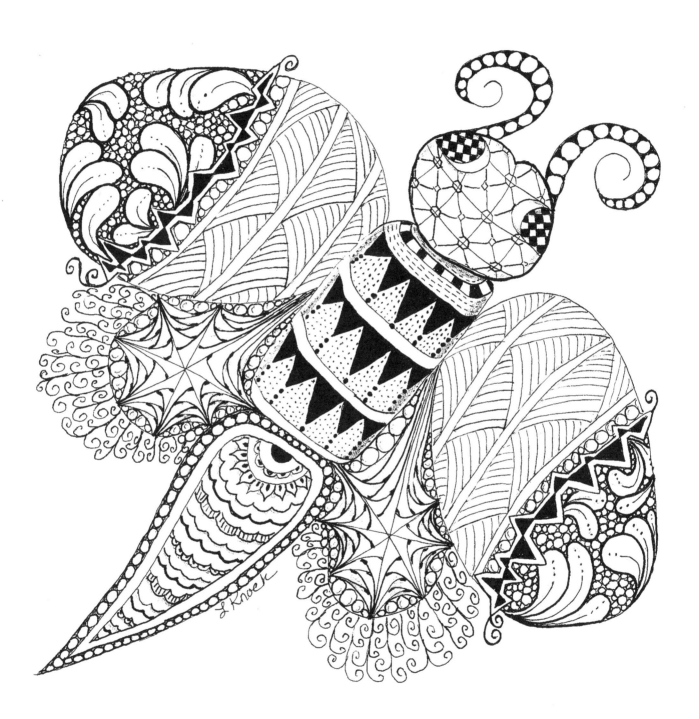

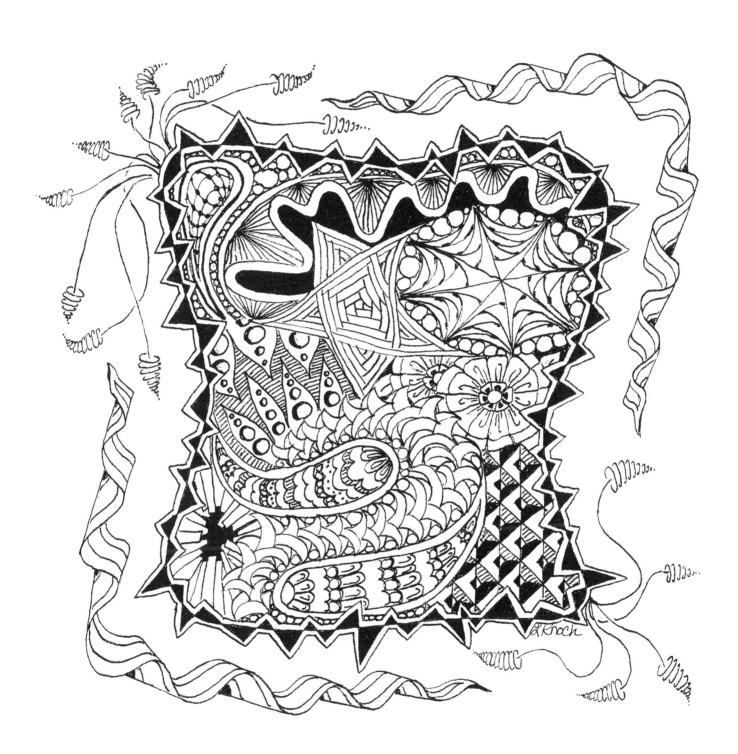

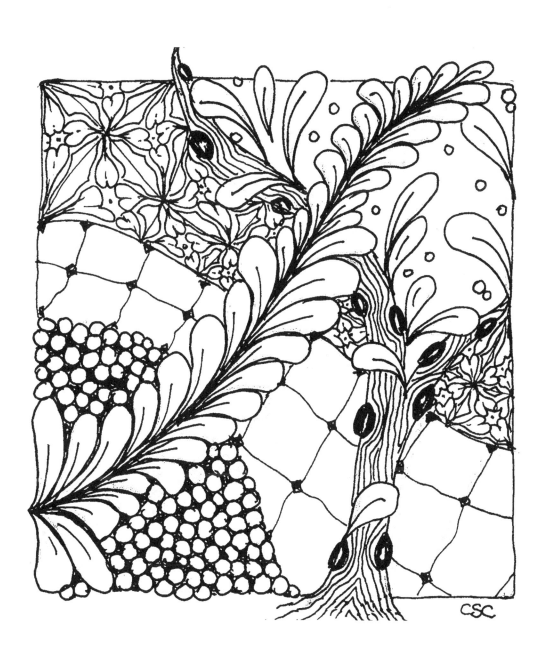

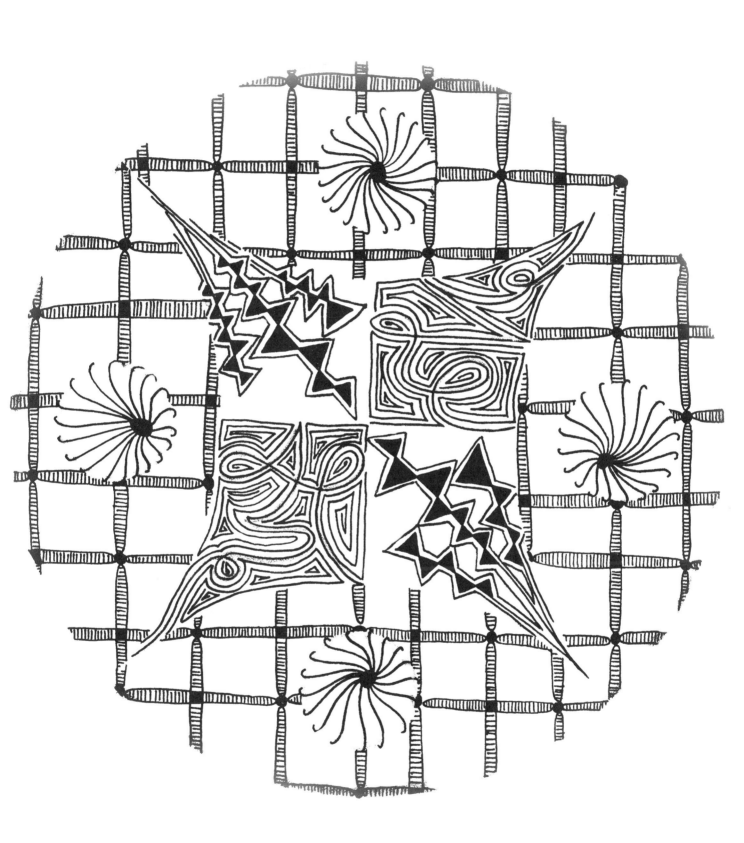

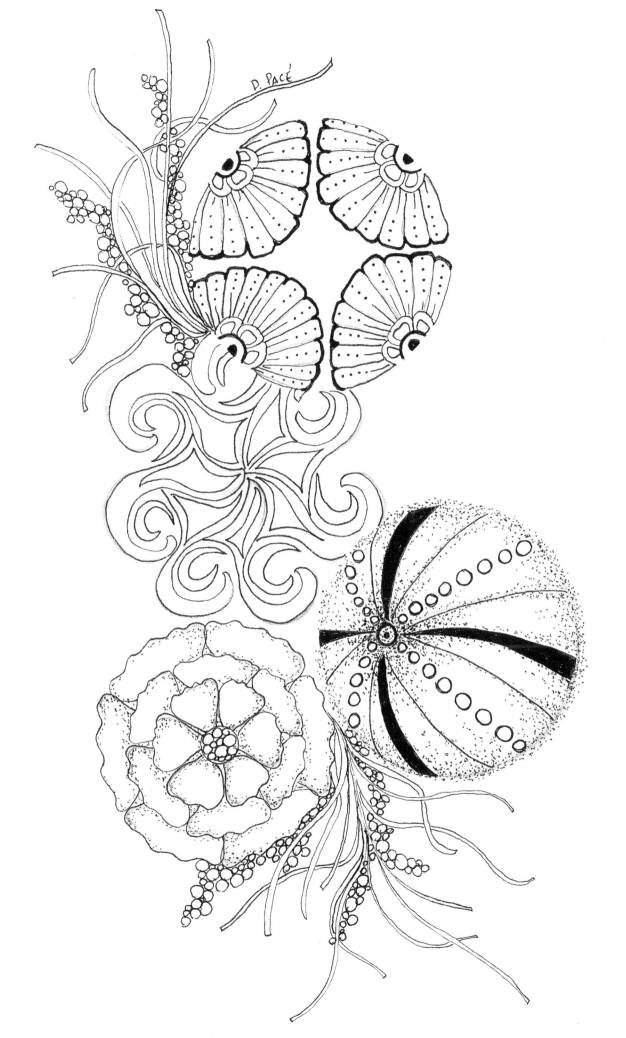

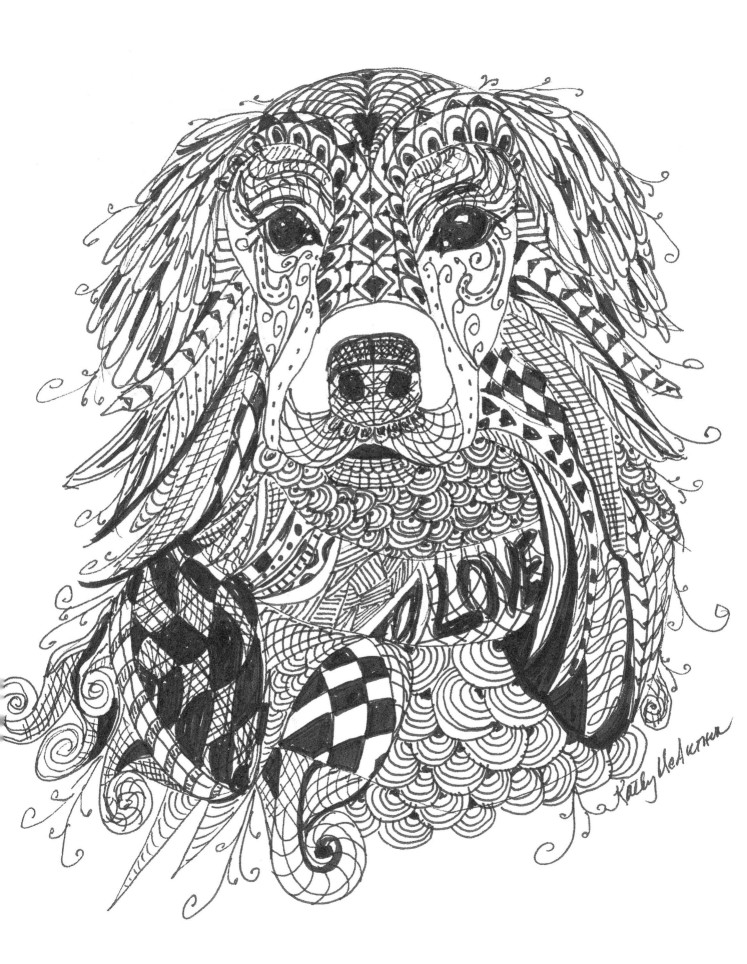

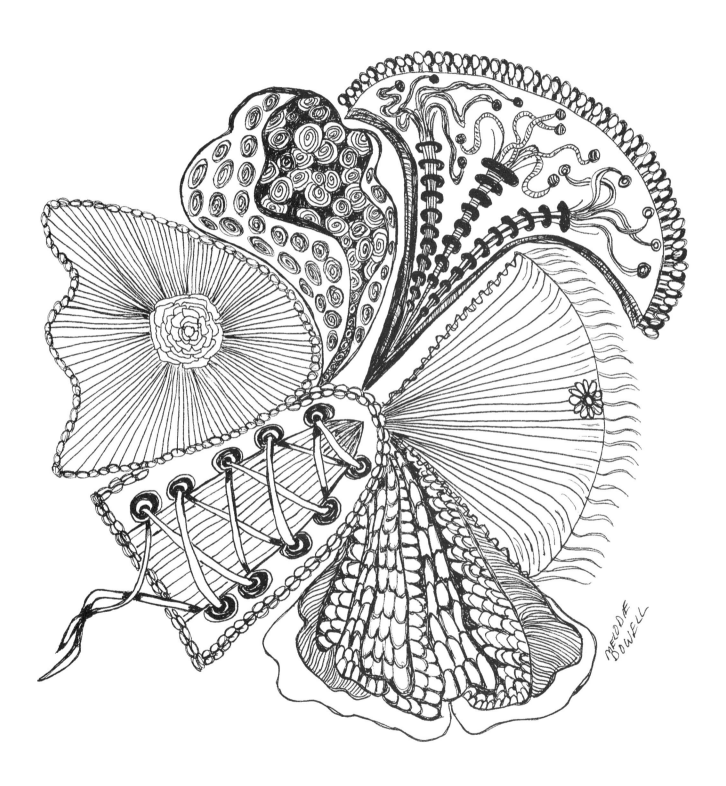

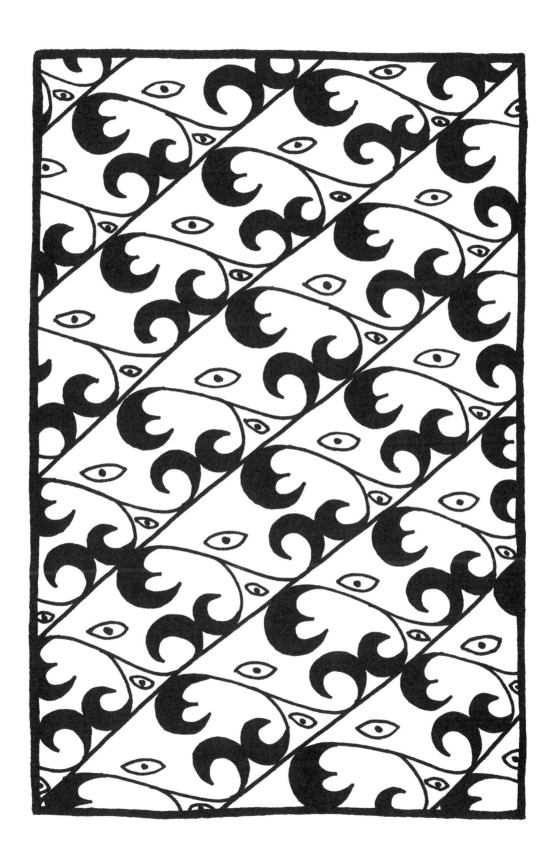

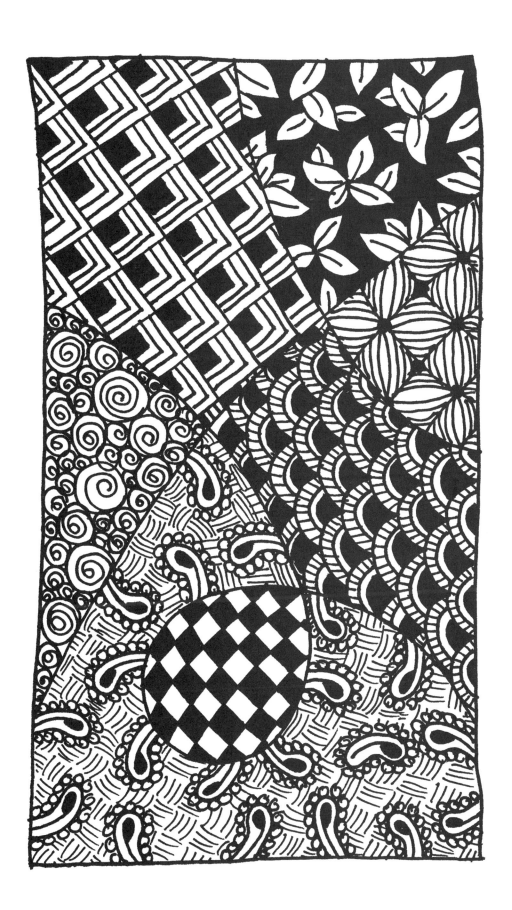

untitled
TRISH REINHART
(FROM CREATIVE TANGLE)
Black sakura Pigma Micron pens and pencil on white cardstock

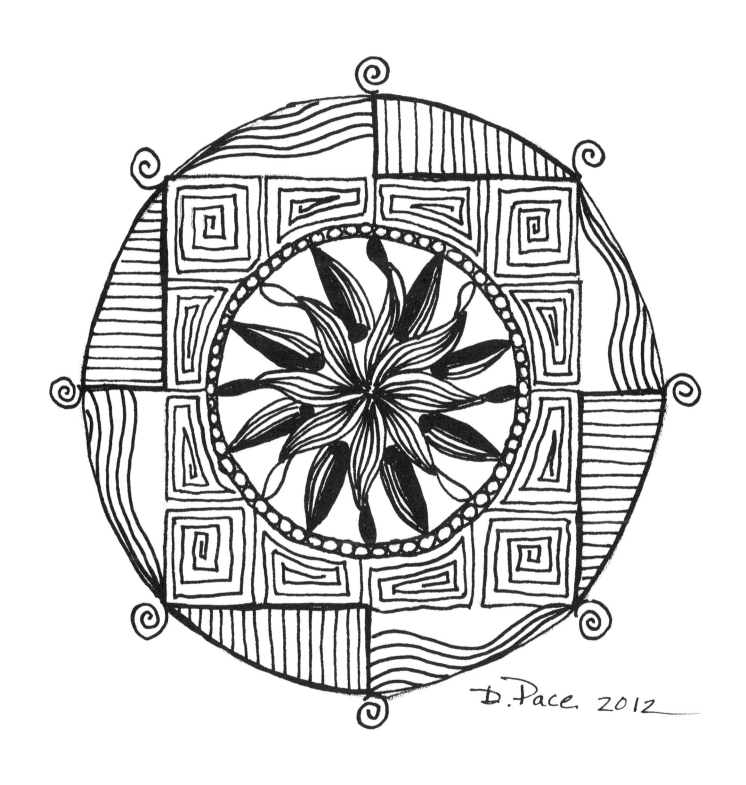

D. Pace. 2012

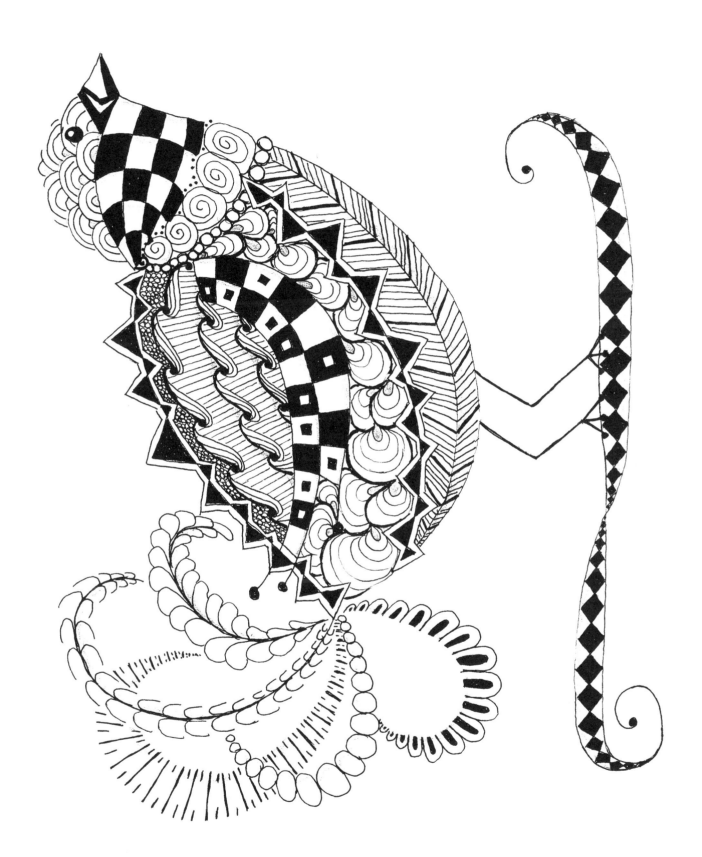

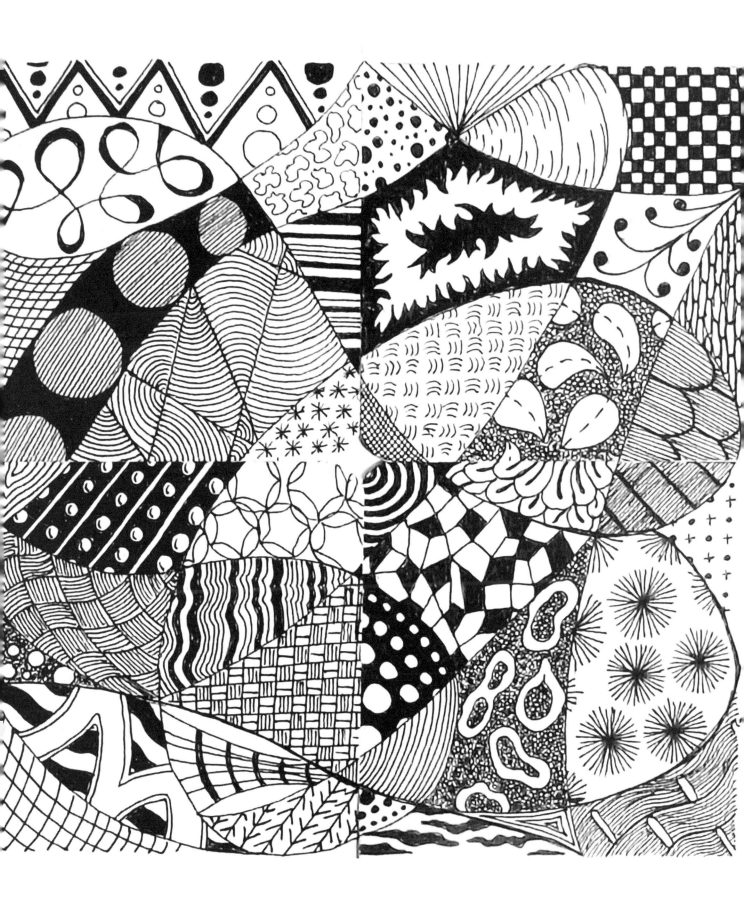

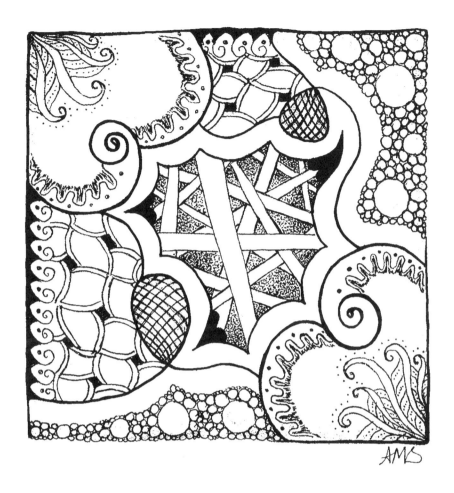

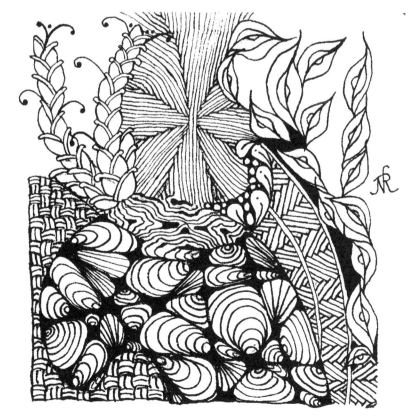

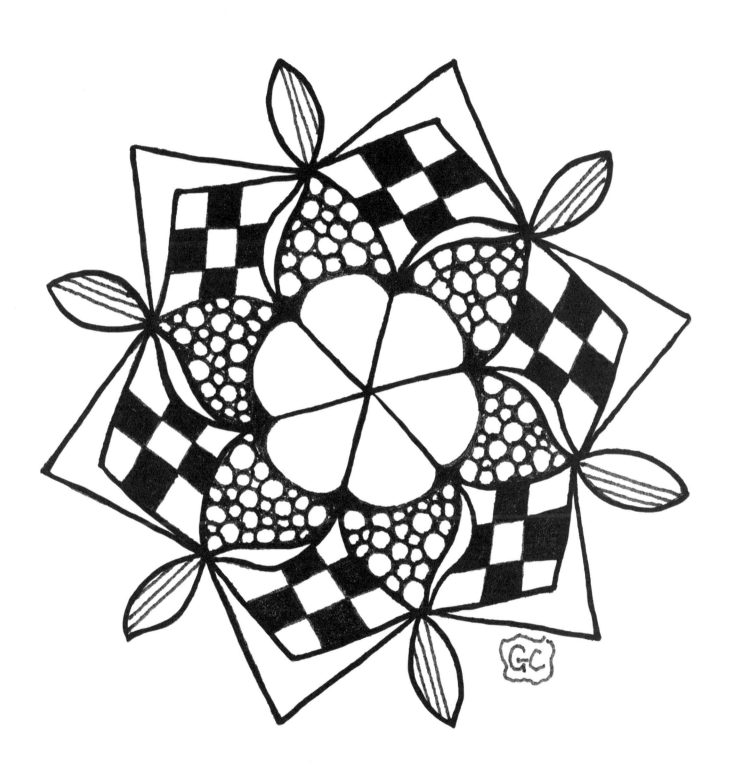

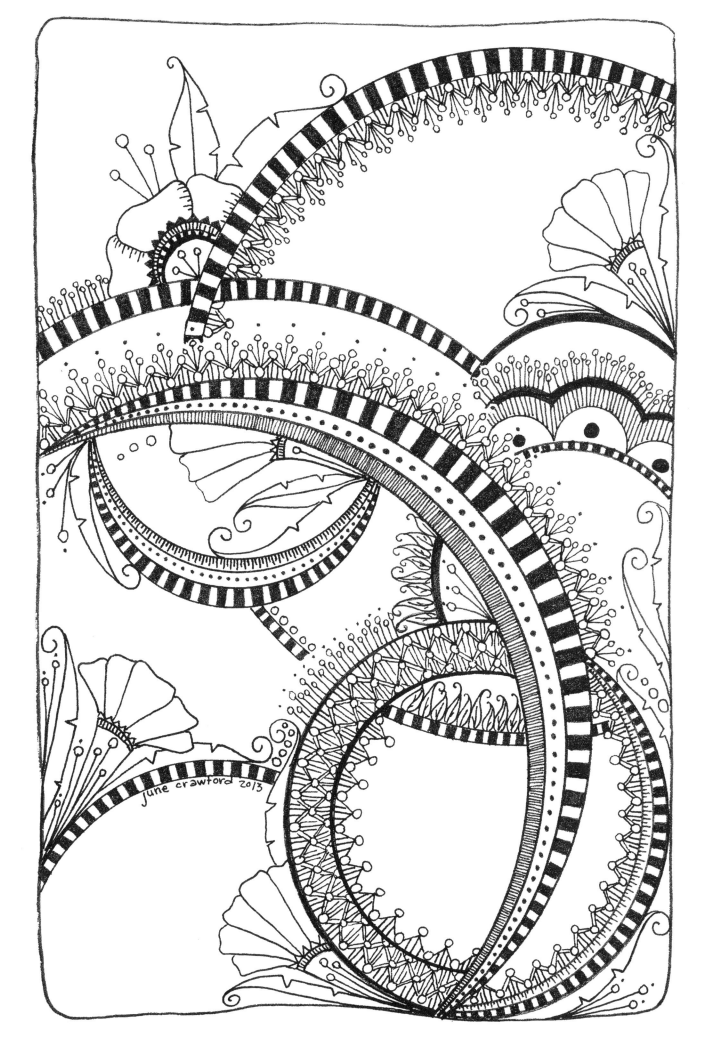

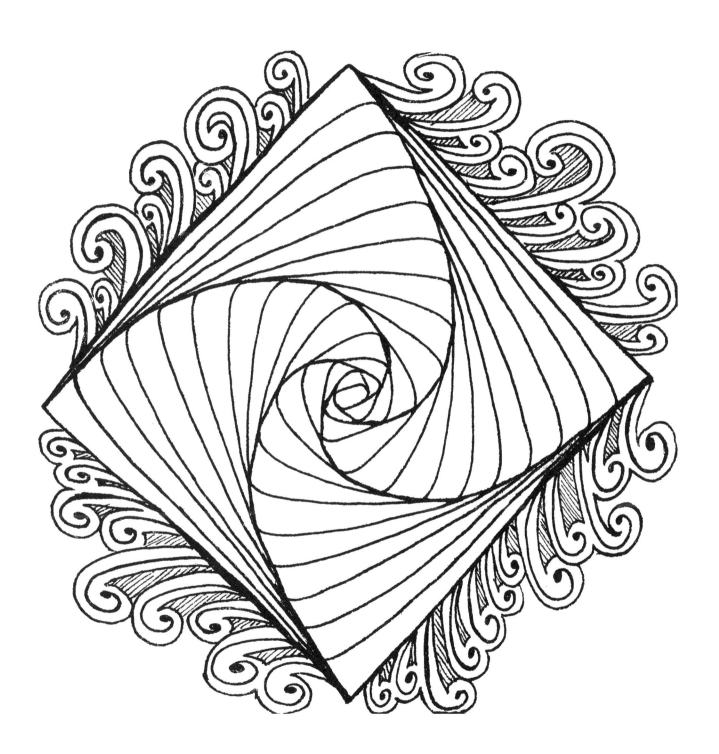

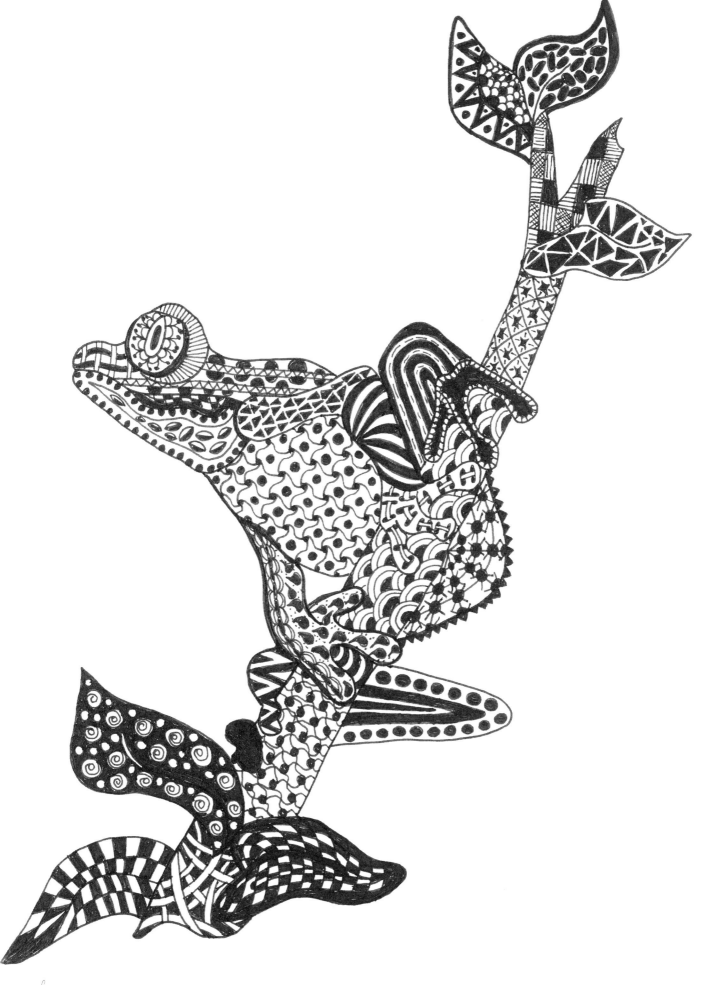

B. Sartain

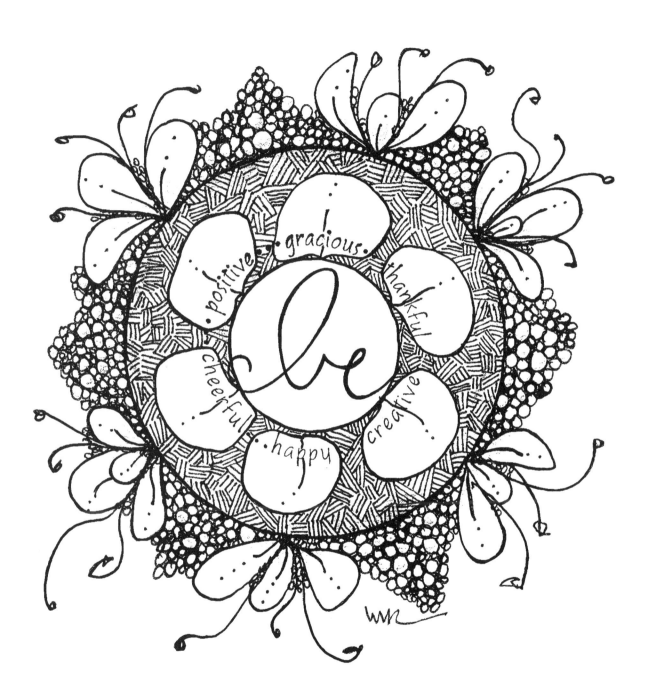

PREVIOUS PAGE:

Be
VALENTINE WERCHANOWSKYJ ROCHÉ
(FROM ZEN DOODLE: OODLES OF DOODLES)
sakura pigma micron pen and rubber stamps on watercolor paper

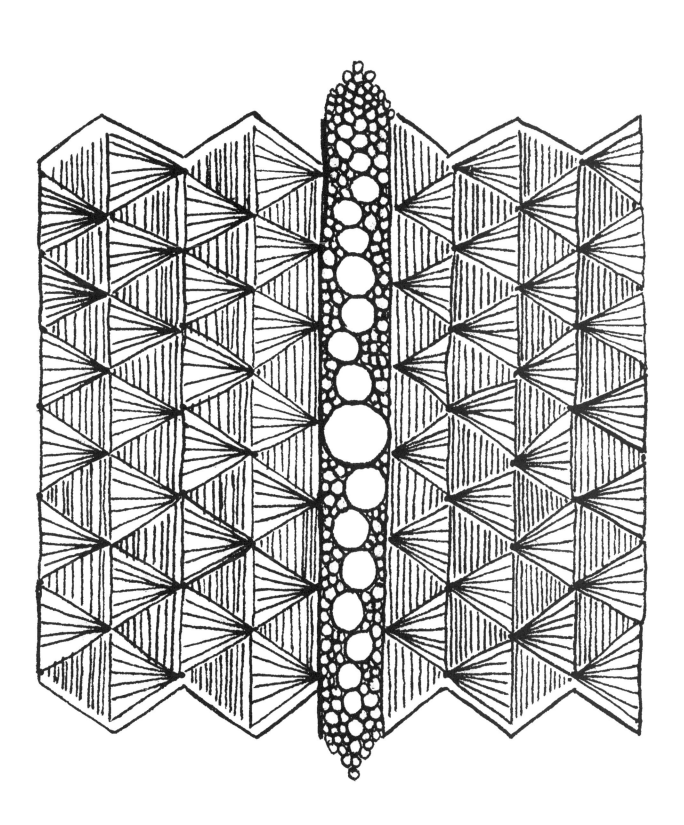

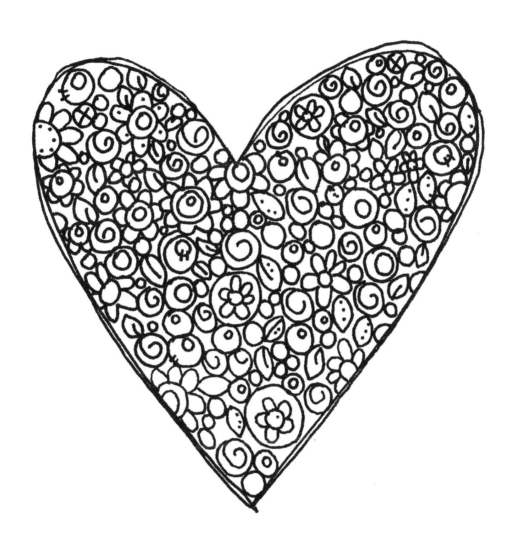

A Full Heart
STEPHANIE ACKERMAN
(FROM ZEN DOODLE: TONS OF TANGLES)
Prismacolor Premier marker on strathmore smooth bristol paper

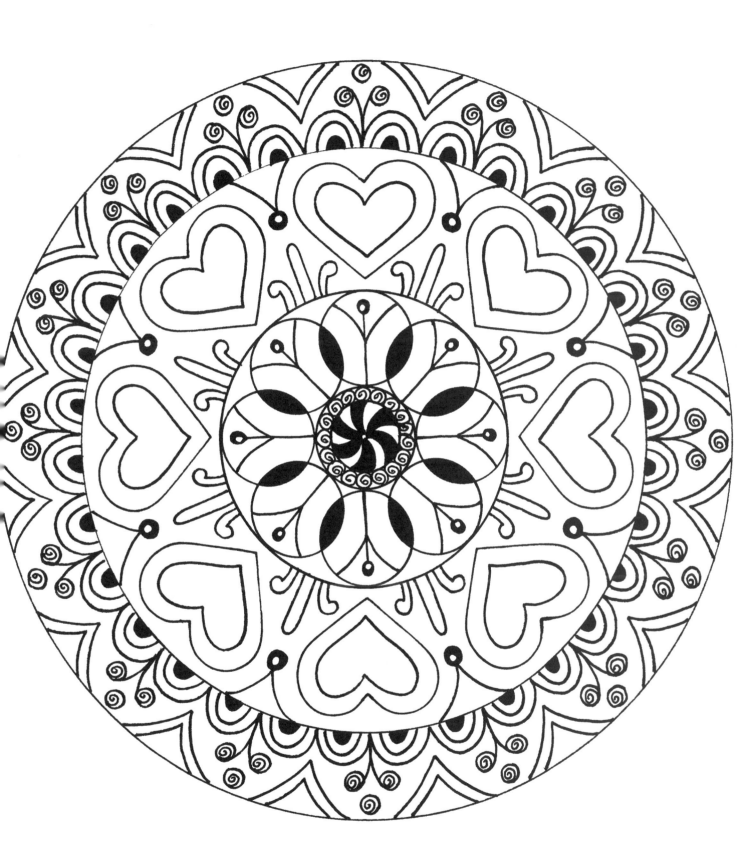

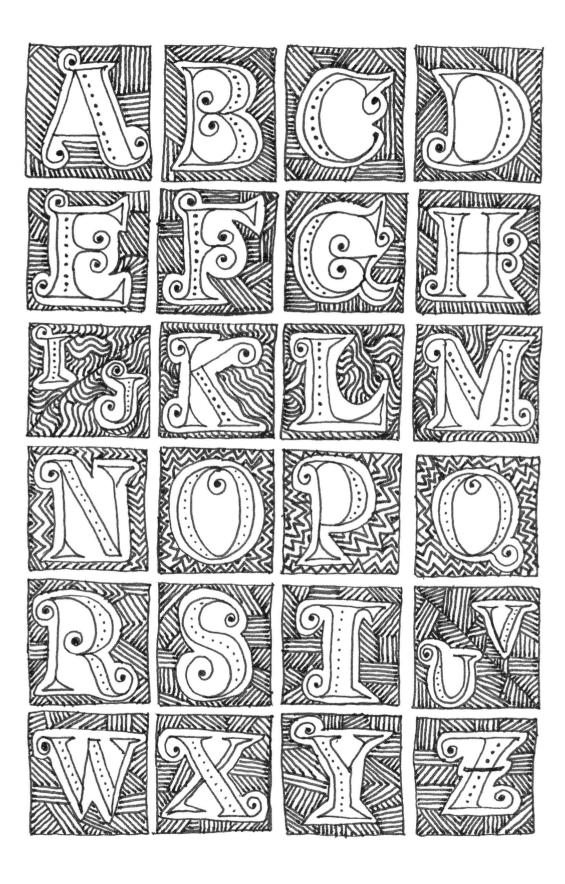

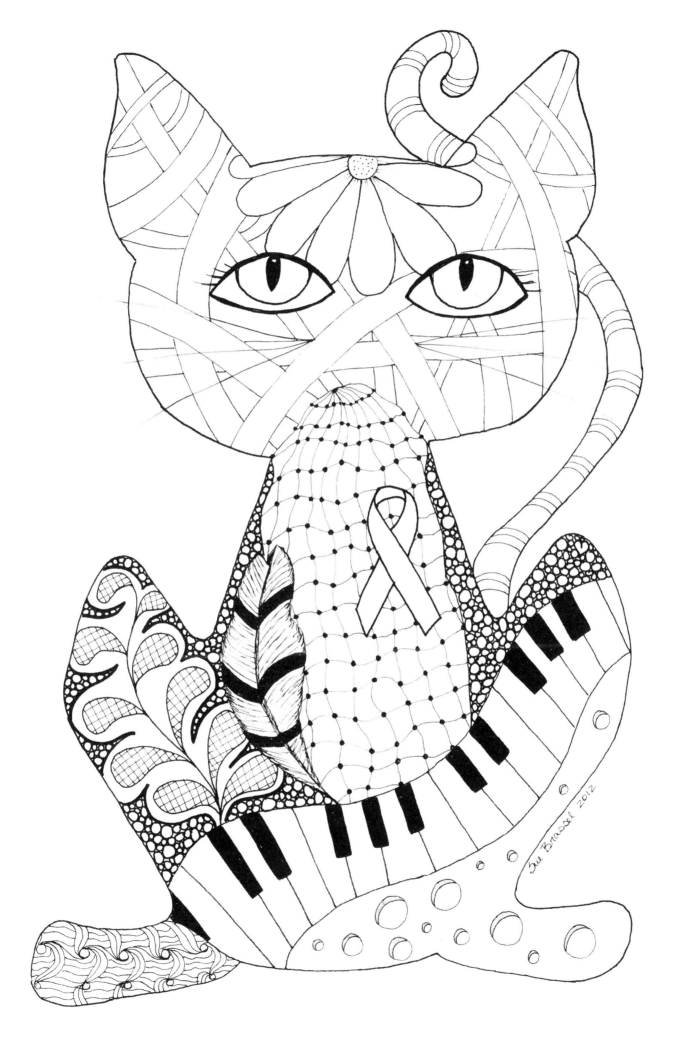

PREVIOUS PAGE:
karen's Hope
SUE BRASSEL
(FROM ZEN DOODLE: TONS OF TANGLES)
sakura pigma micron pen watercolor paper

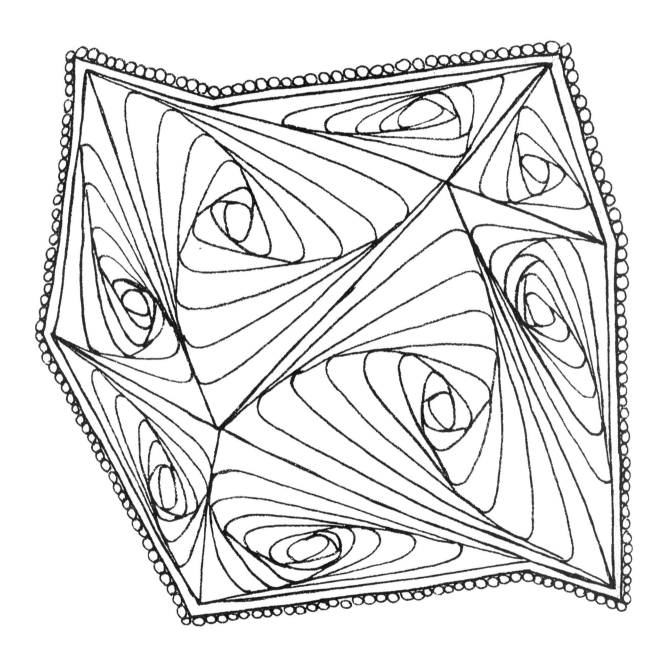

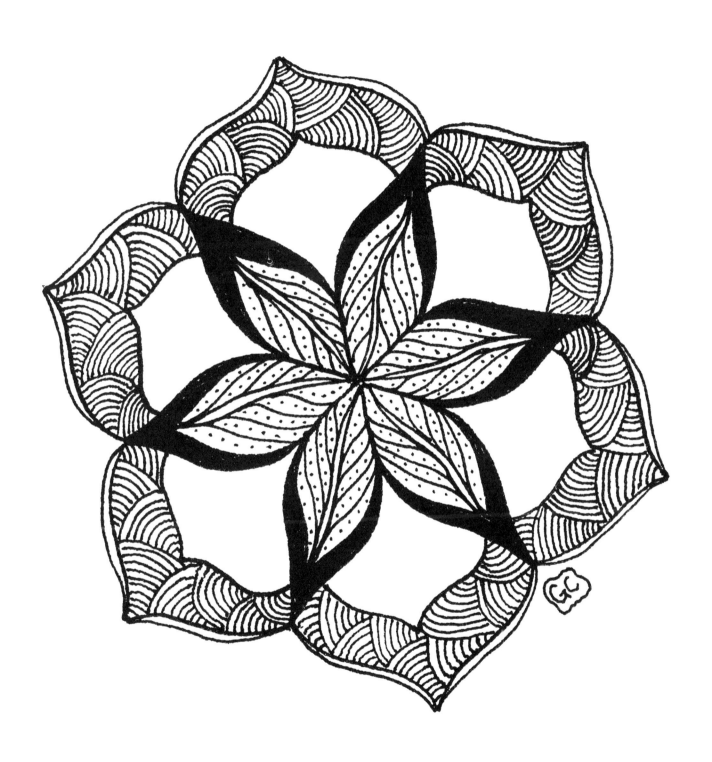

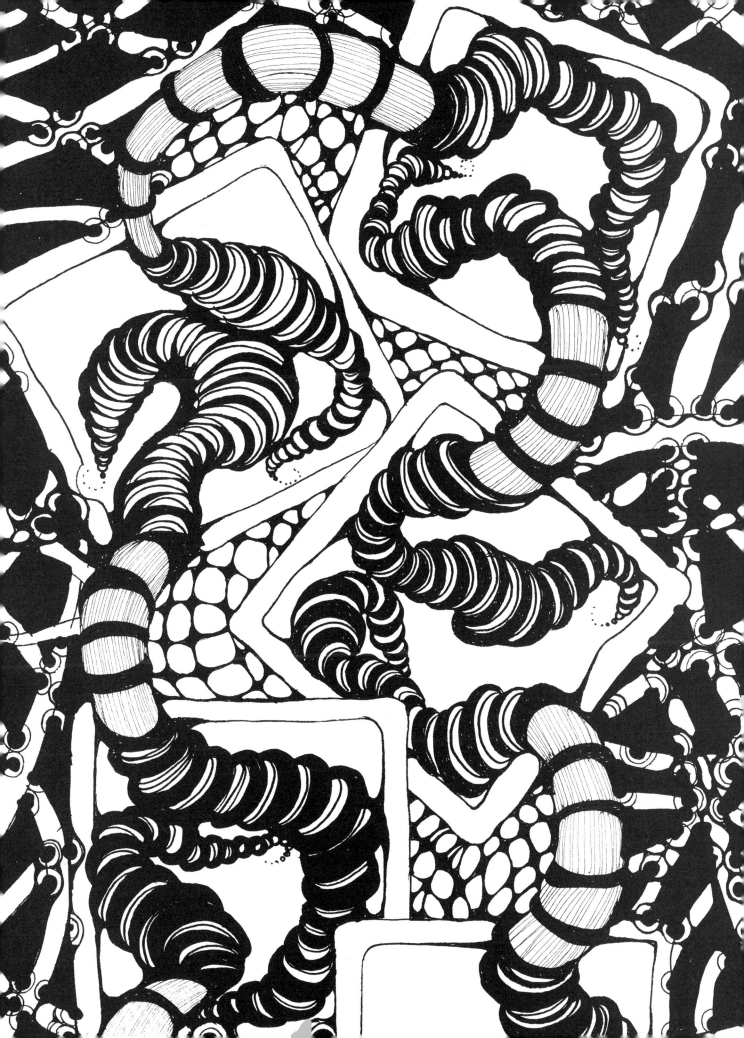

connections
SUSAN CIRIGLIANO
(FROM ZEN DOODLE: TONS OF TANGLES)
sakura pigma micron pens and graphite pencil on moleskine watercolor sketchbook

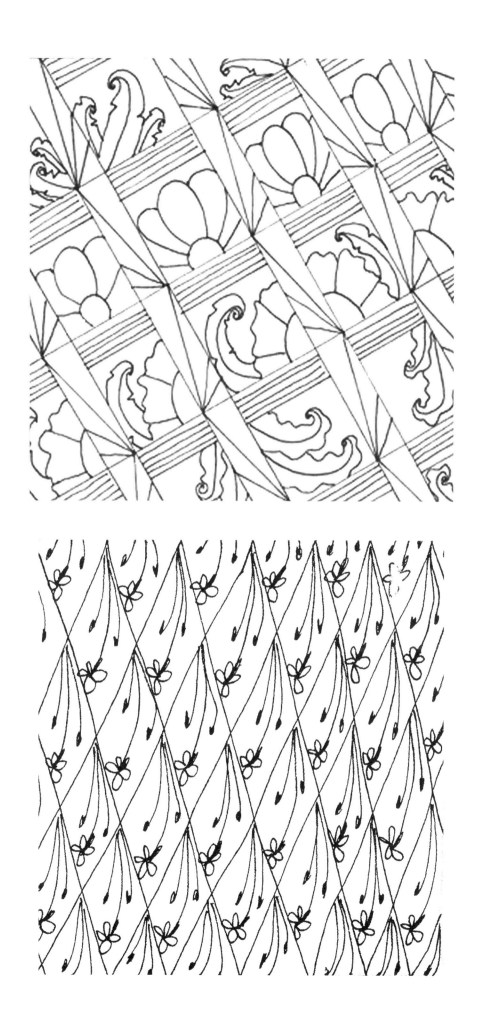

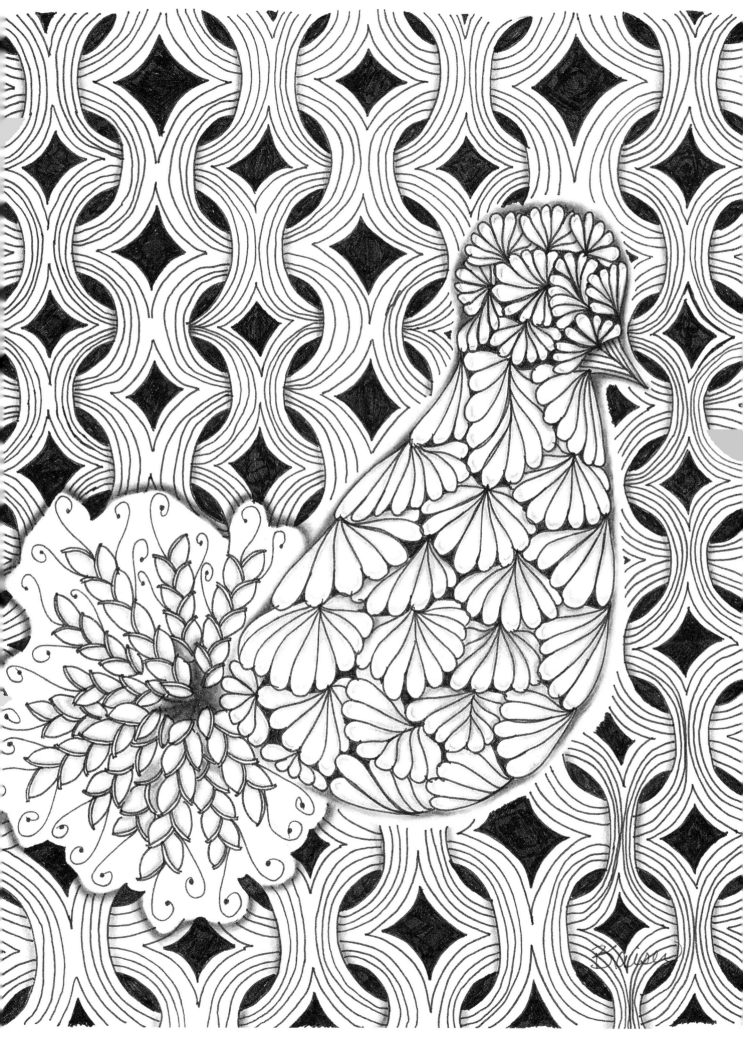

PREVIOUS PAGE:
zentangle® ʙɪrd serɪes—resting
BARBARA KAISER
(FROM ZEN DOODLE: OODLES OF DOODLES)
sharpie fine-point pen, mechanical pencil and charcoal pencil on paper

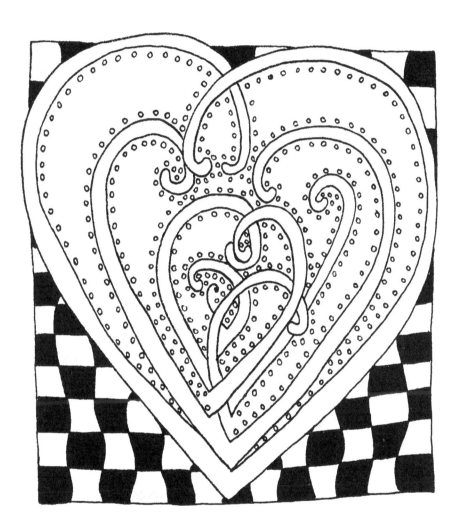

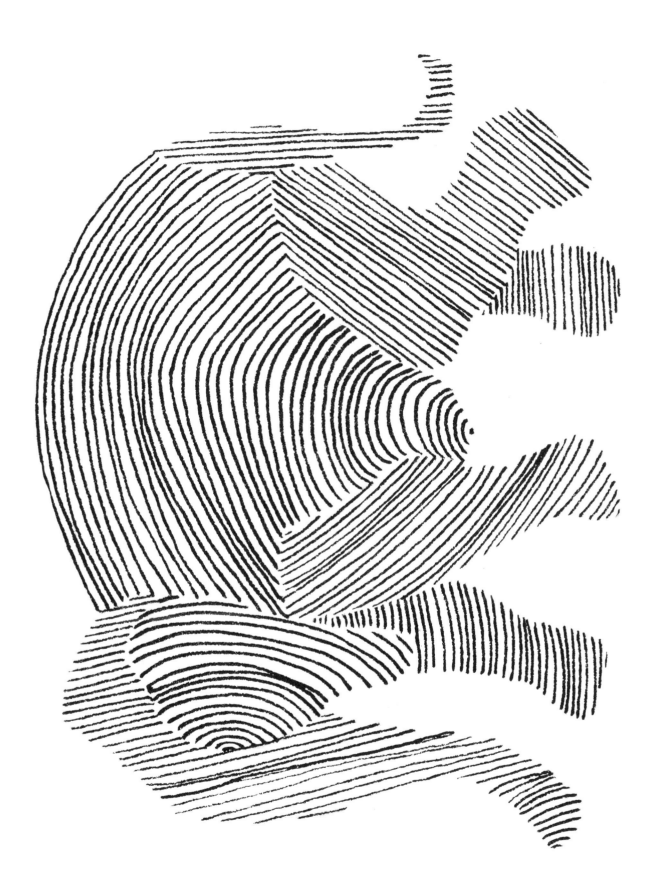

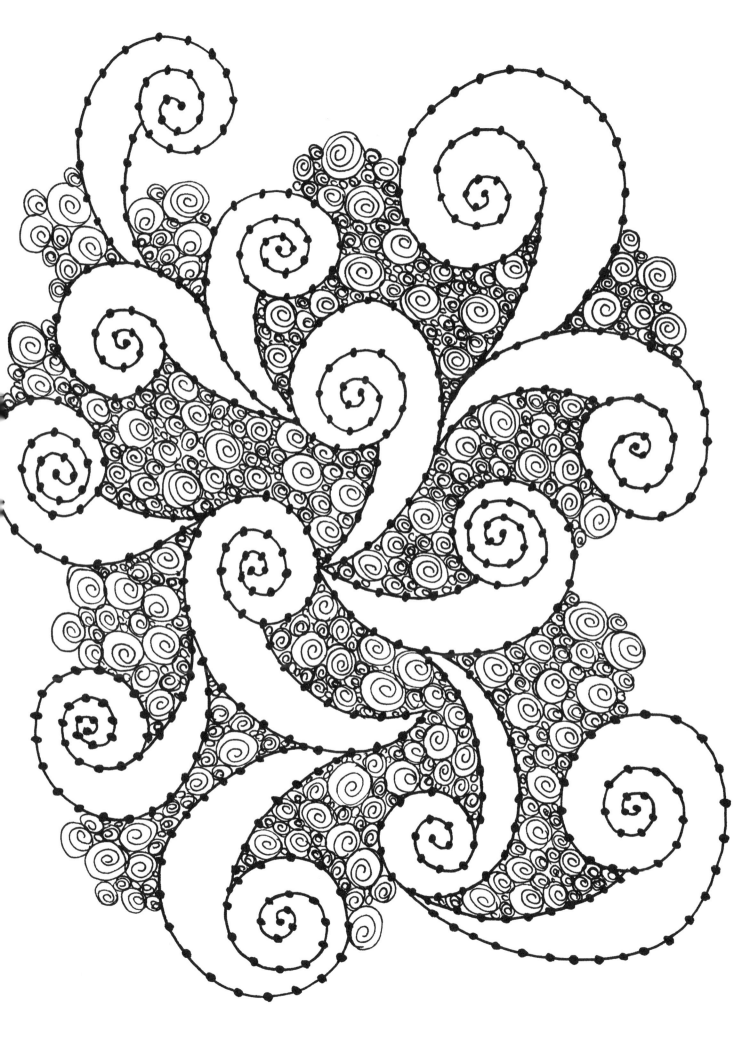

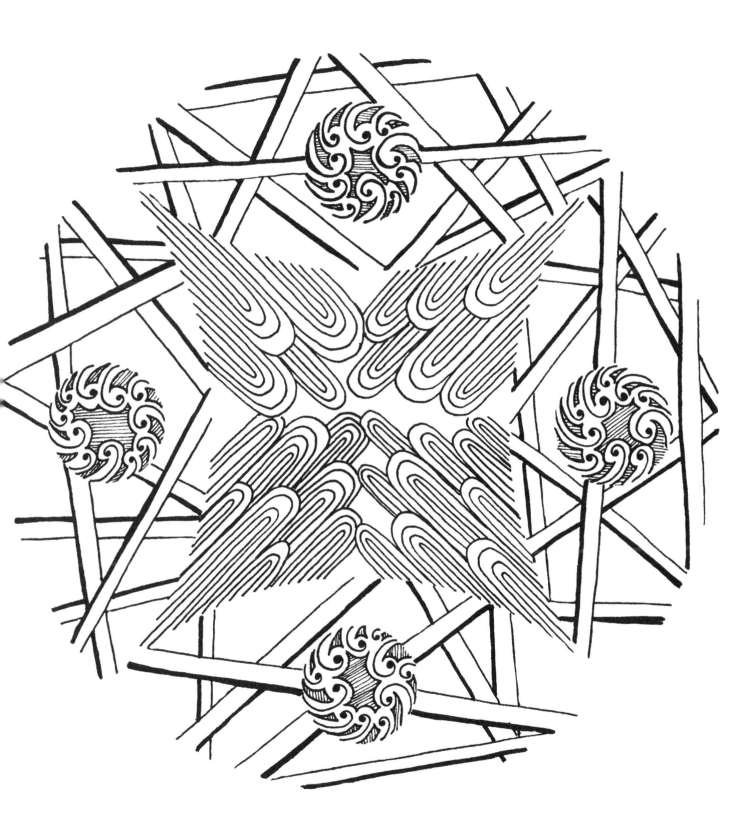

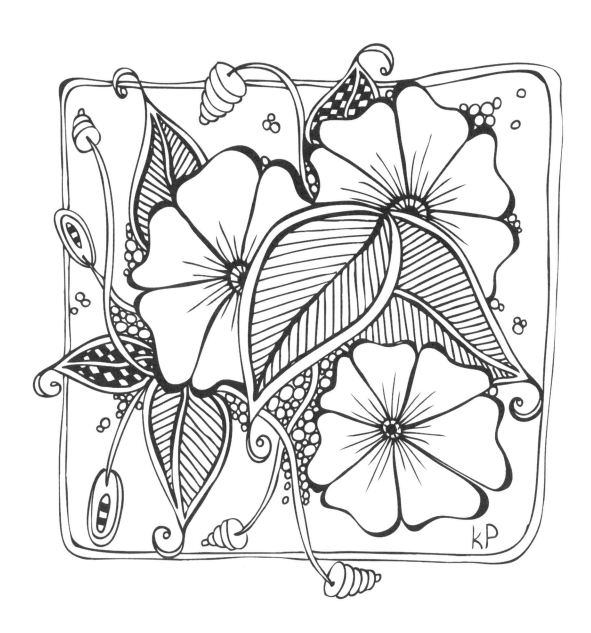

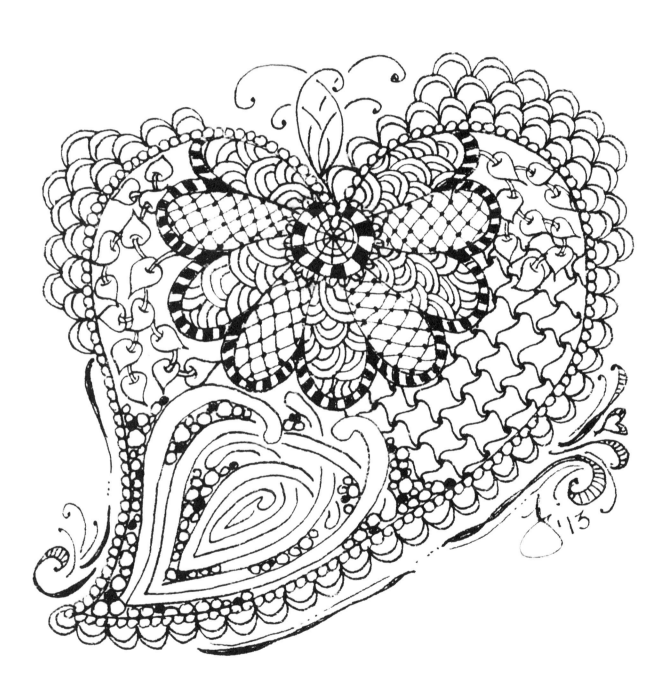

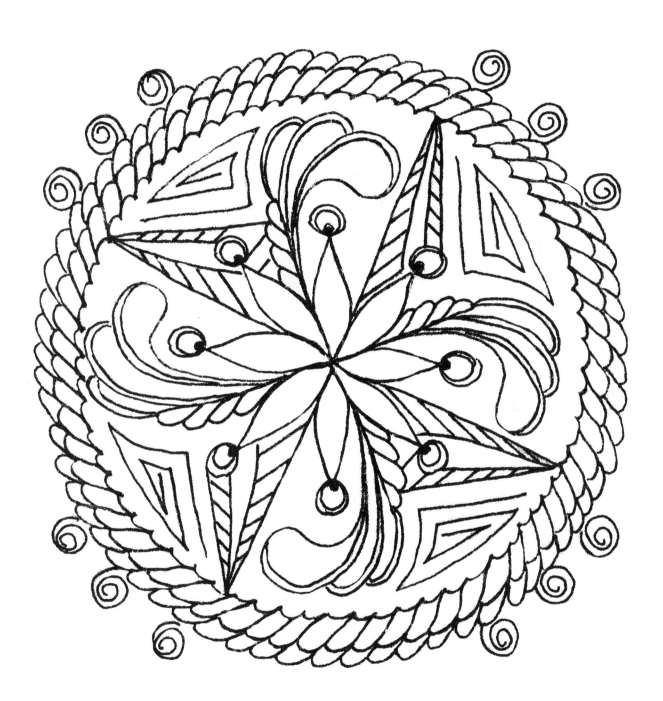

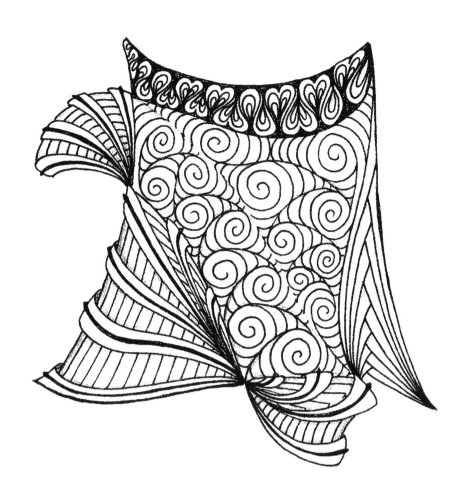

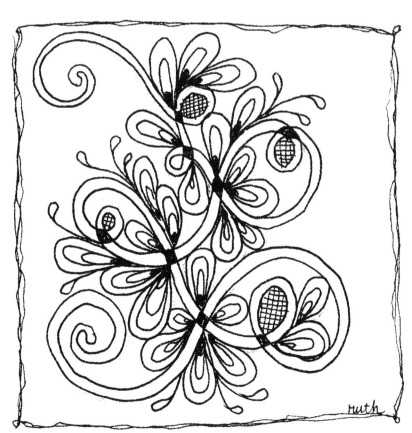

ruth

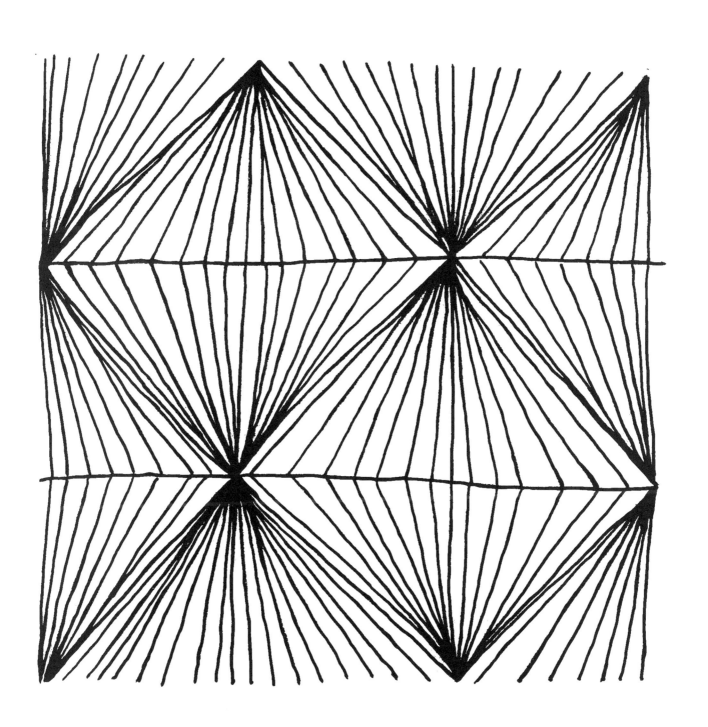

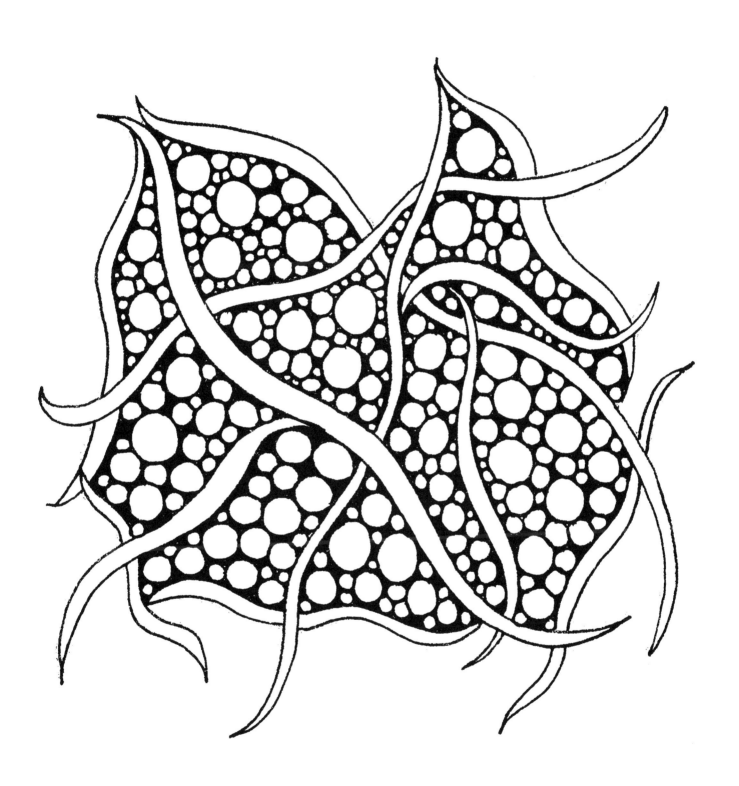

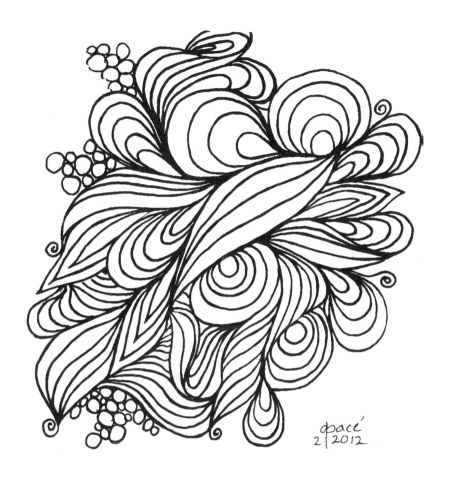

θρacé
2/2012

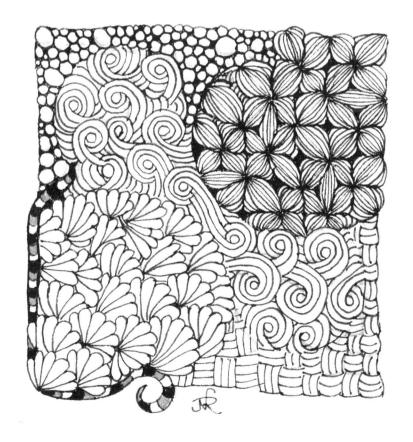

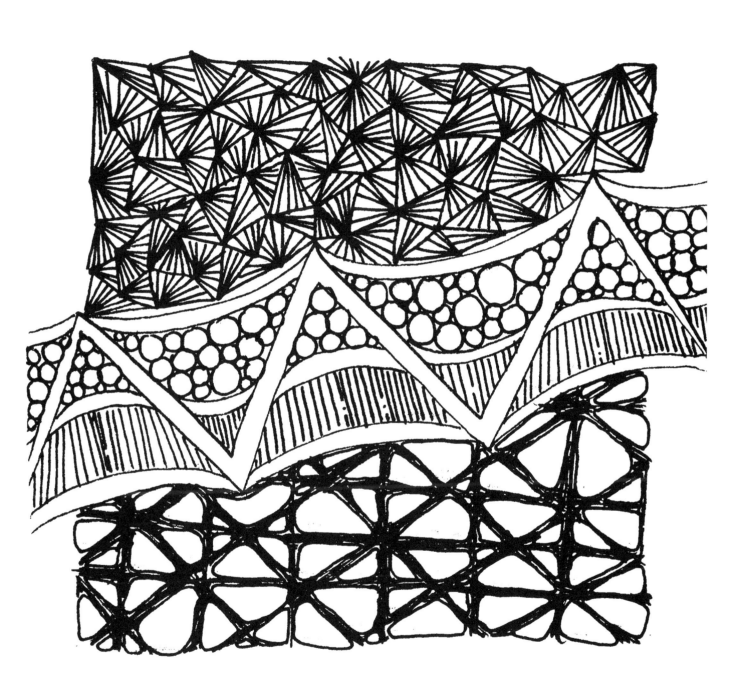

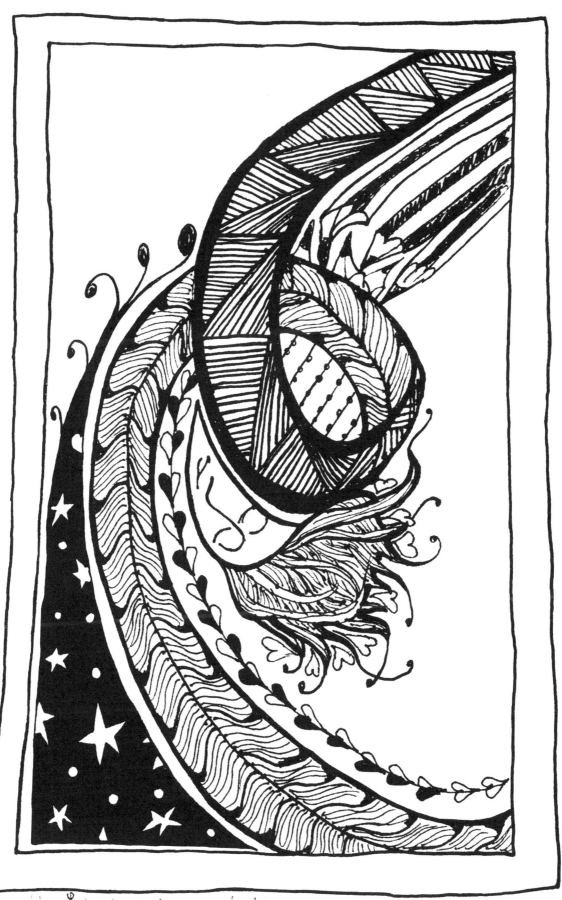

She Lives in a dream World J+A 2012

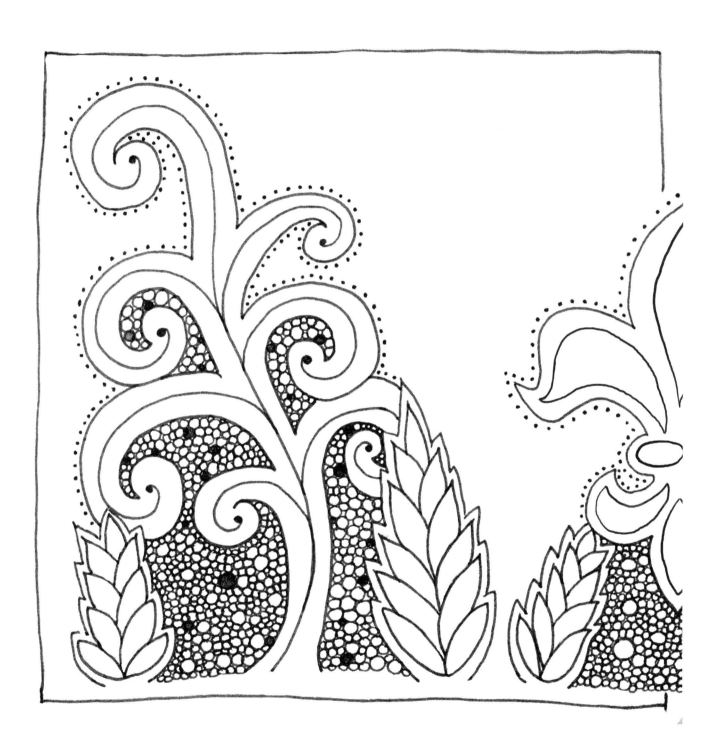

PREVIOUS PAGE:
payne's grey monochrome
KASS HALL
(FROM ZENTANGLE® UNTANGLED)
sakura pigma micron pen, ink and rubber stamp on zentangle® tile

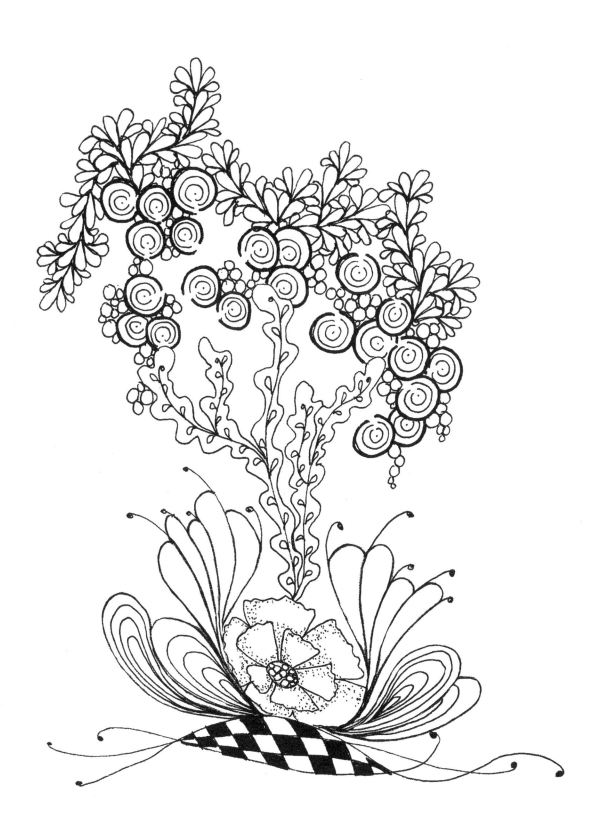

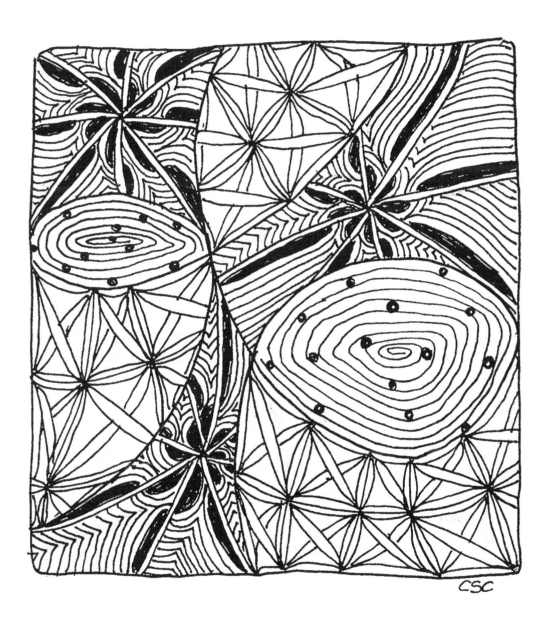

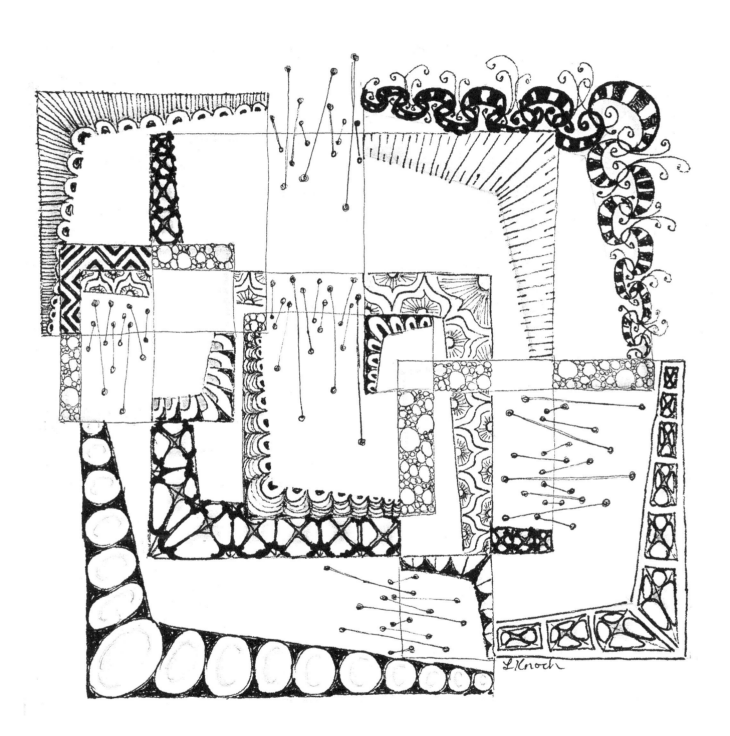

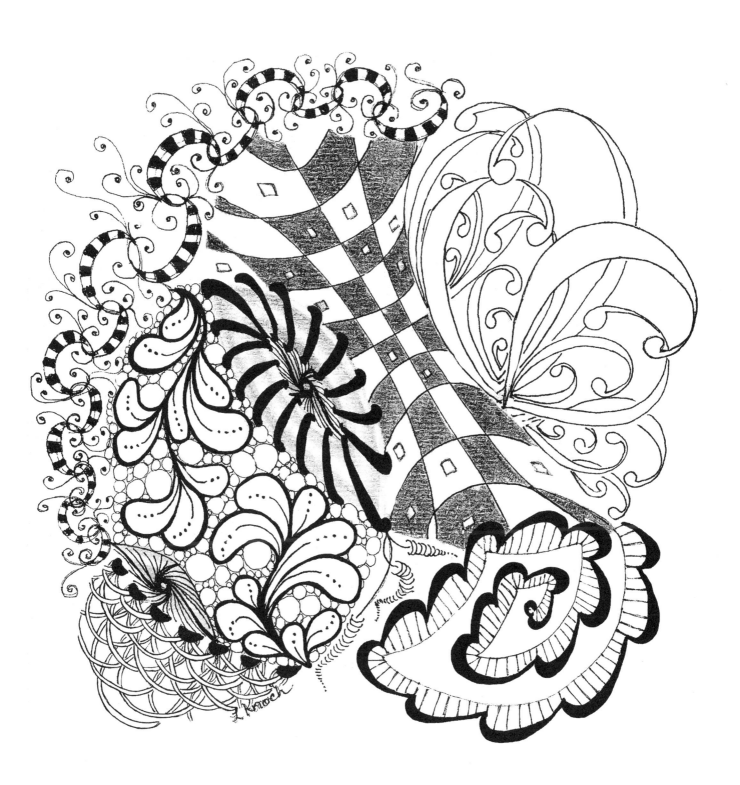

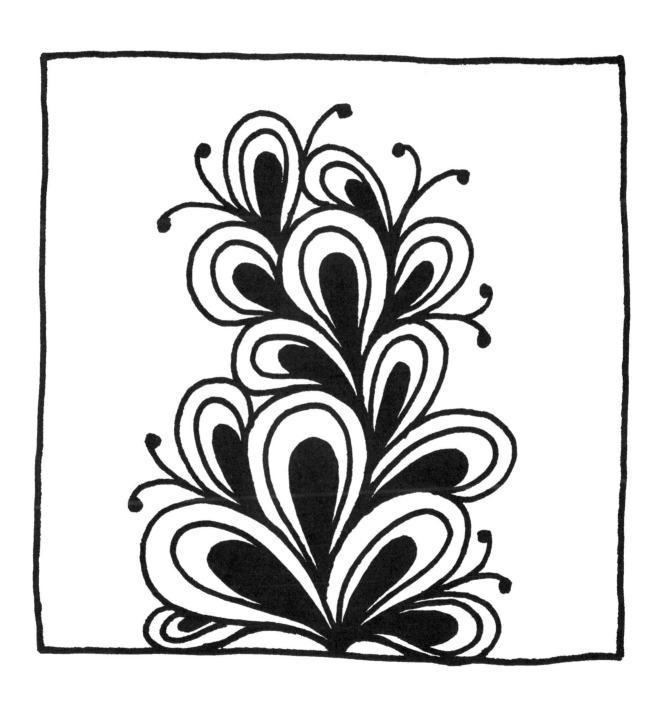

PREVIOUS PAGE:
País
TRISH REINHART
(FROM CREATIVE TANGLE)

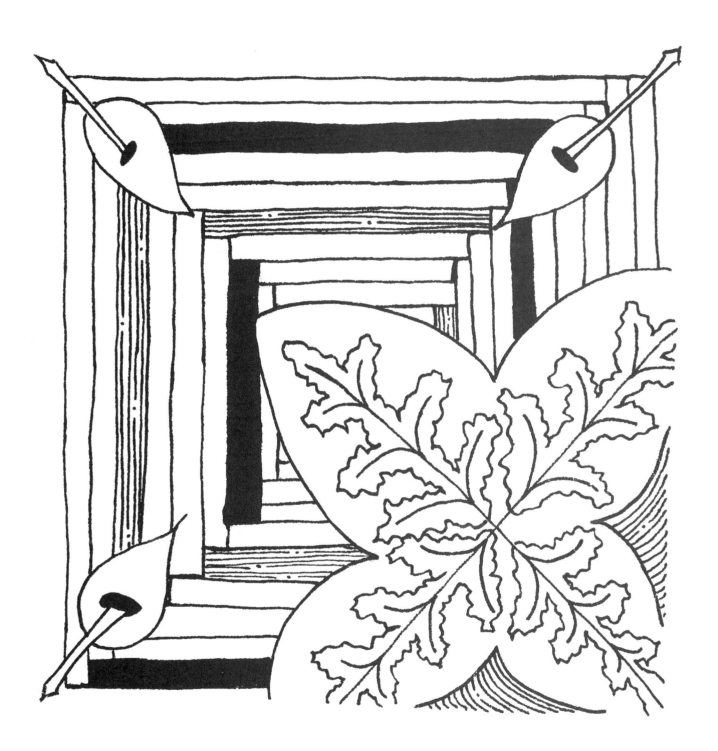

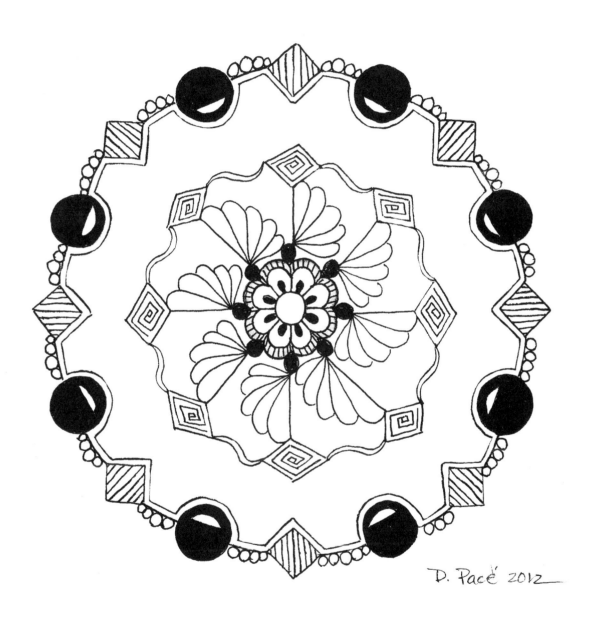

D. Pacé 2012

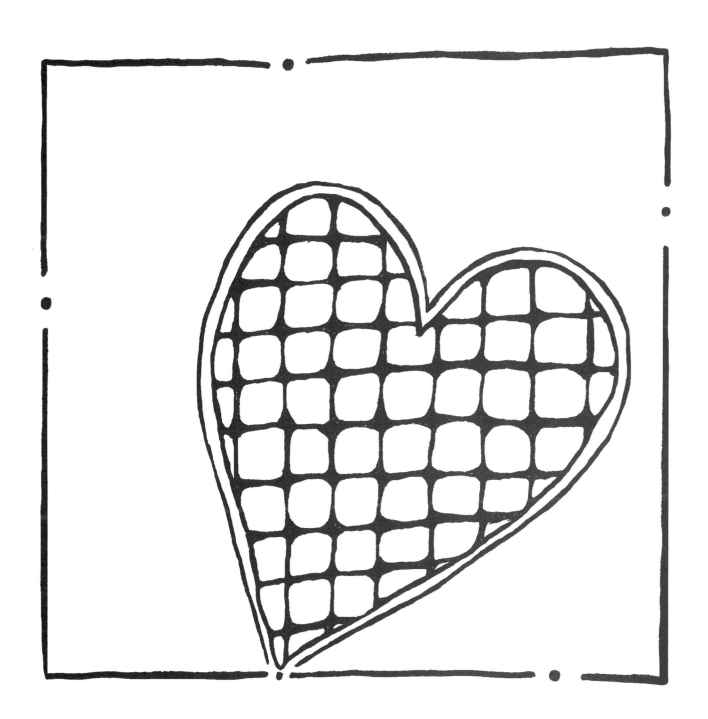

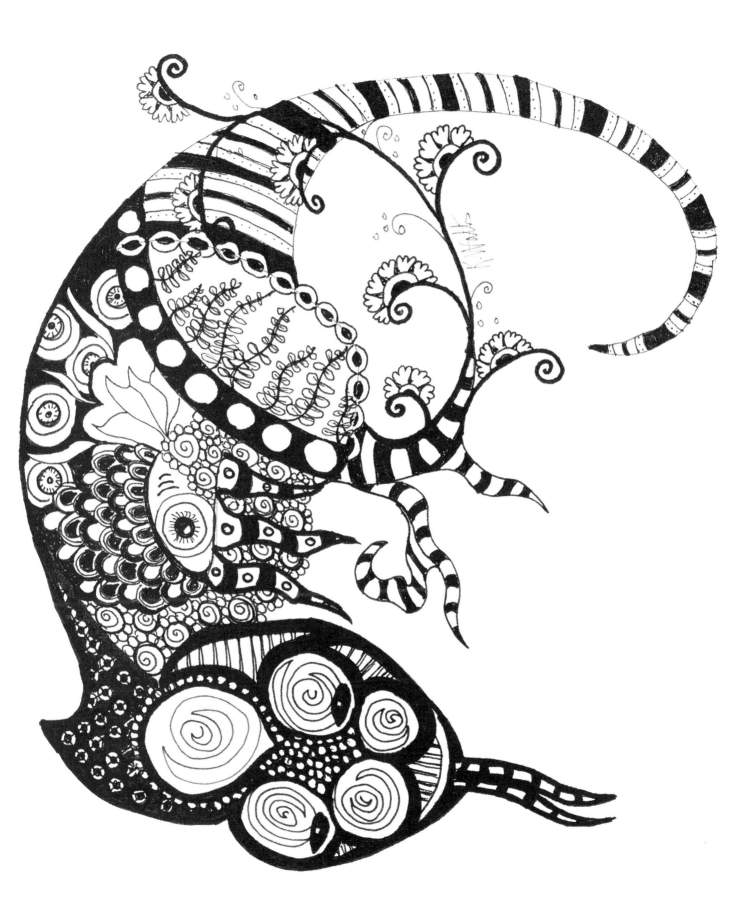

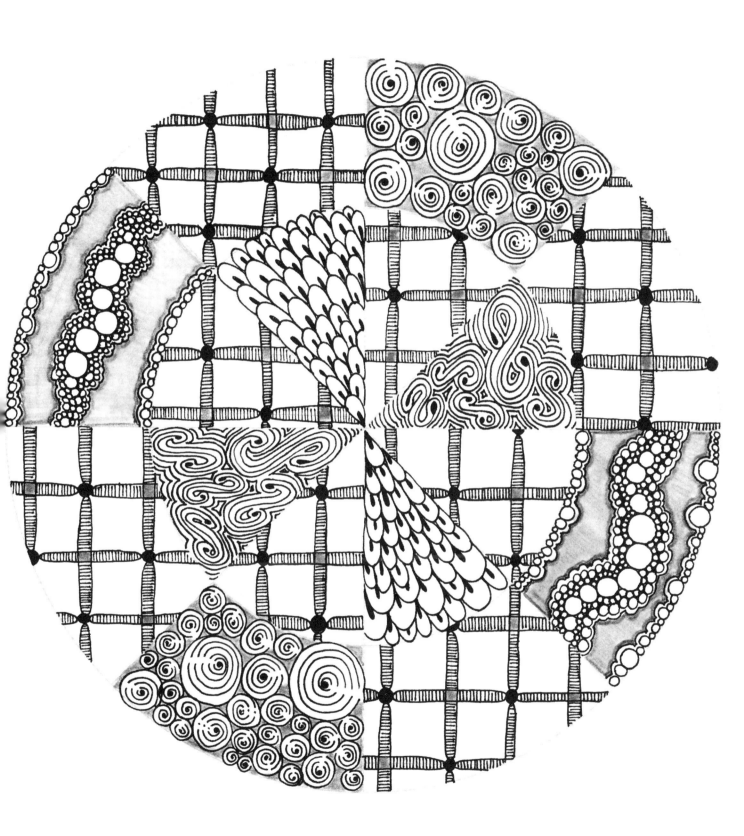

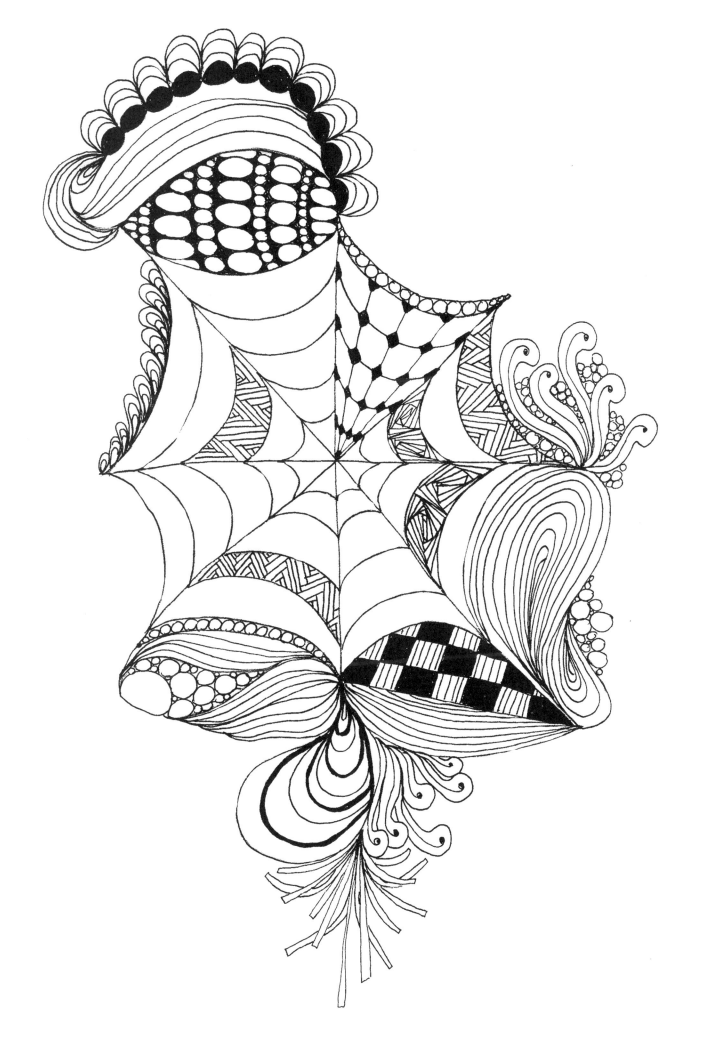

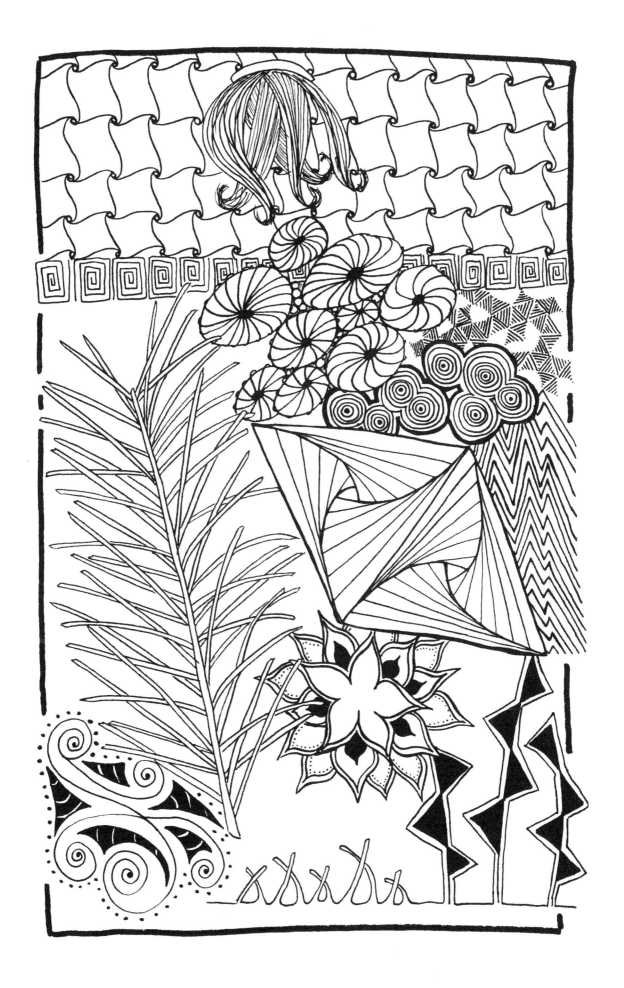

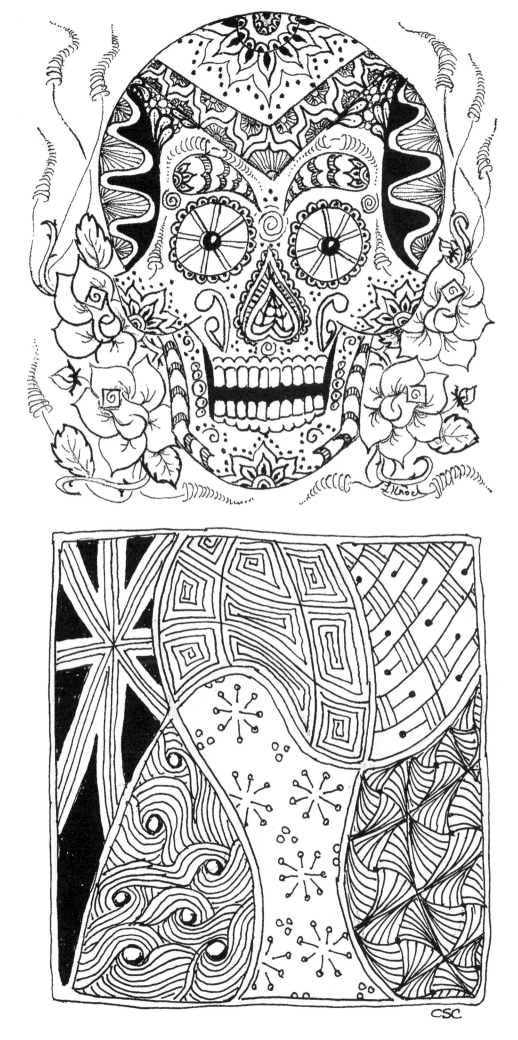

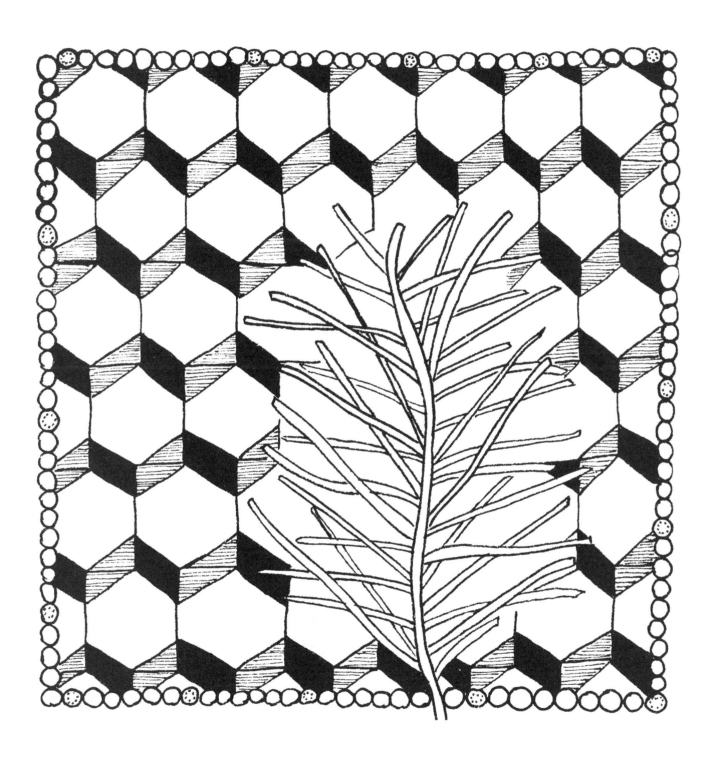

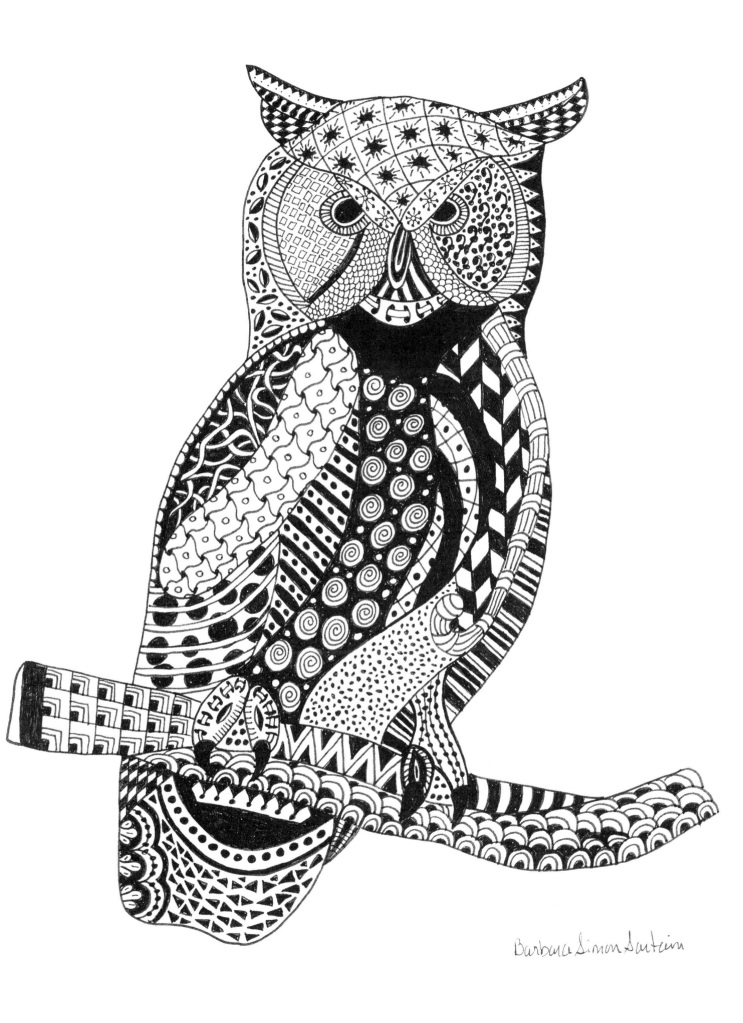

Barbara Simon Sartain

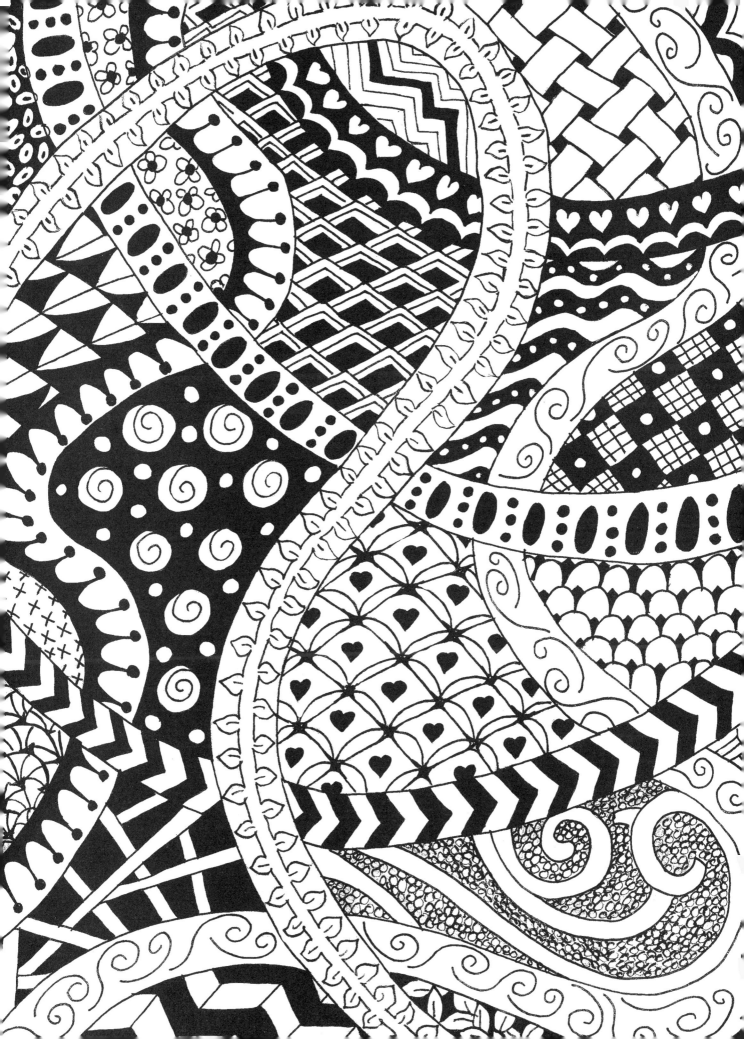

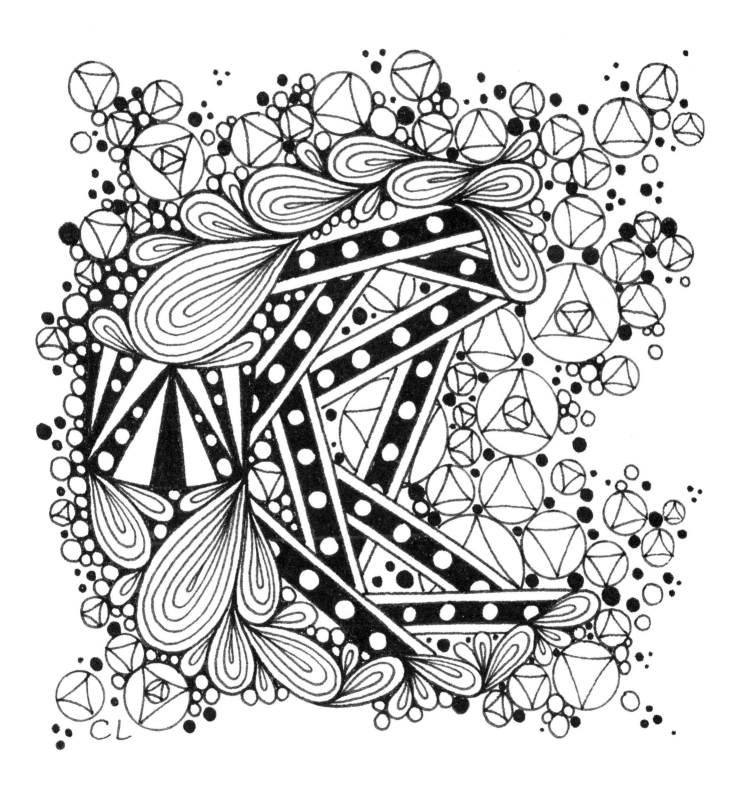

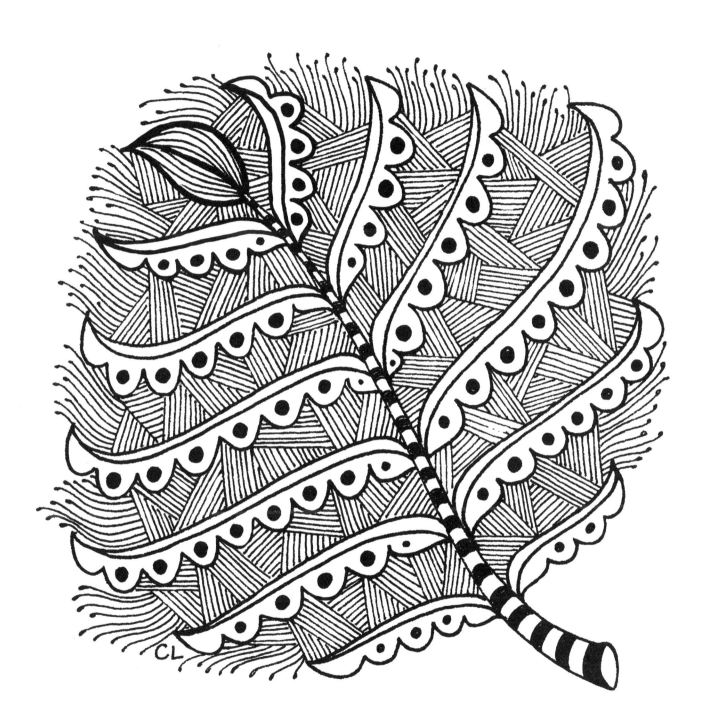

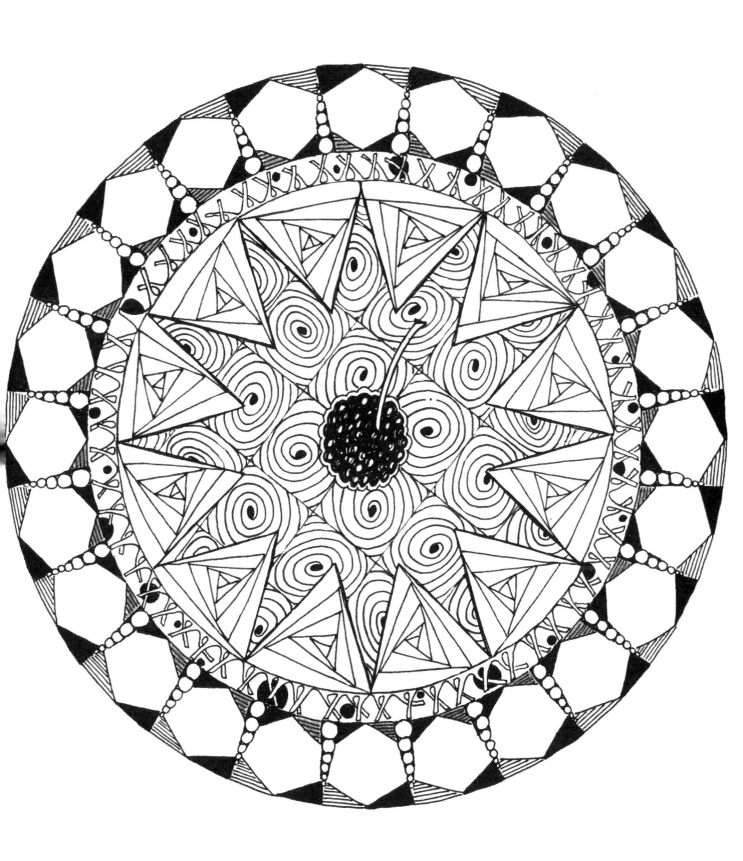

PREVIOUS PAGE:
Honeycomb zendala
KASS HALL
(FROM THE ZENTANGLE® UNTANGLED WORKBOOK)
includes the following tangle patterns: Honeycomb, paradox, bronx cheer, bumper, tipple

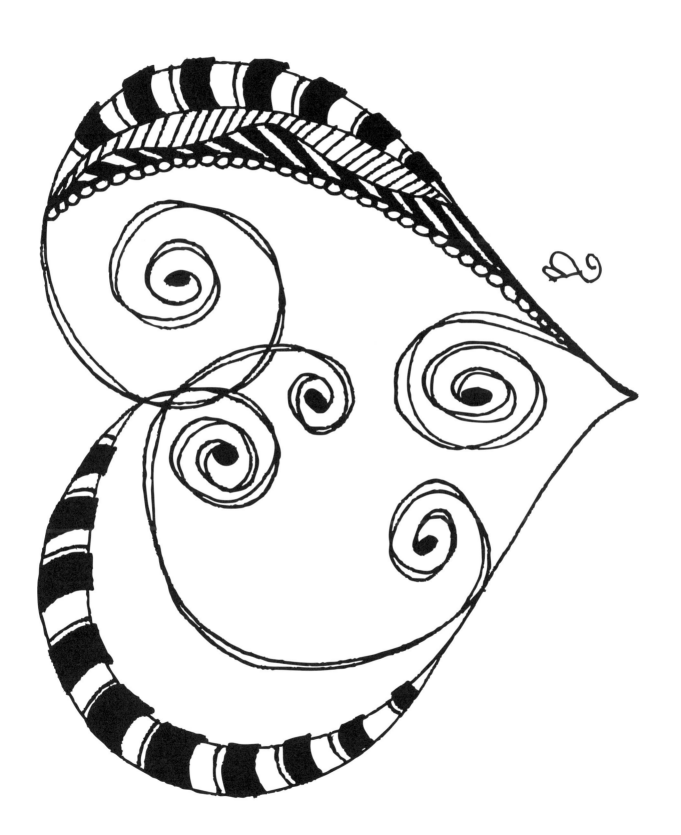

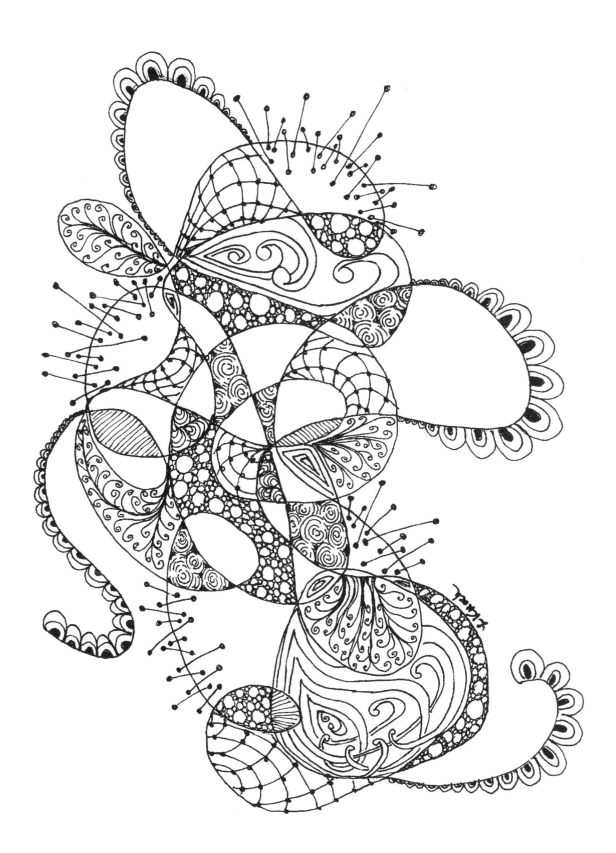

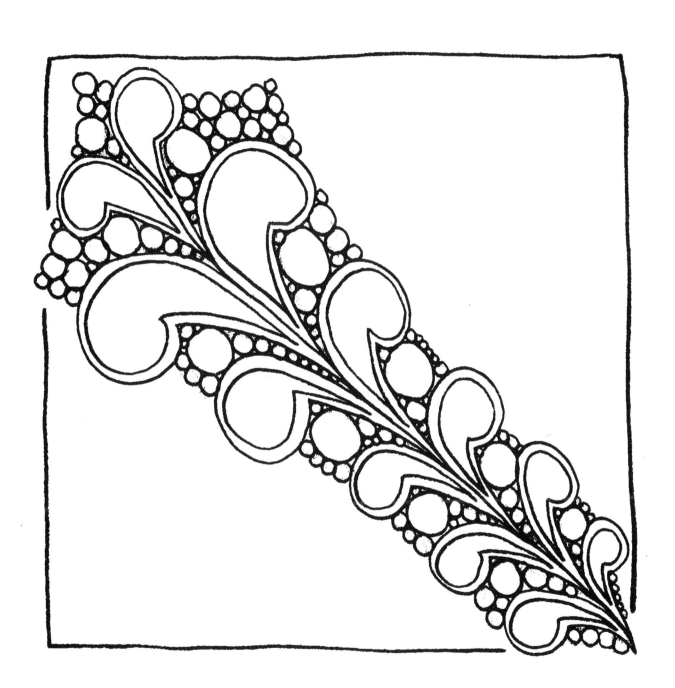

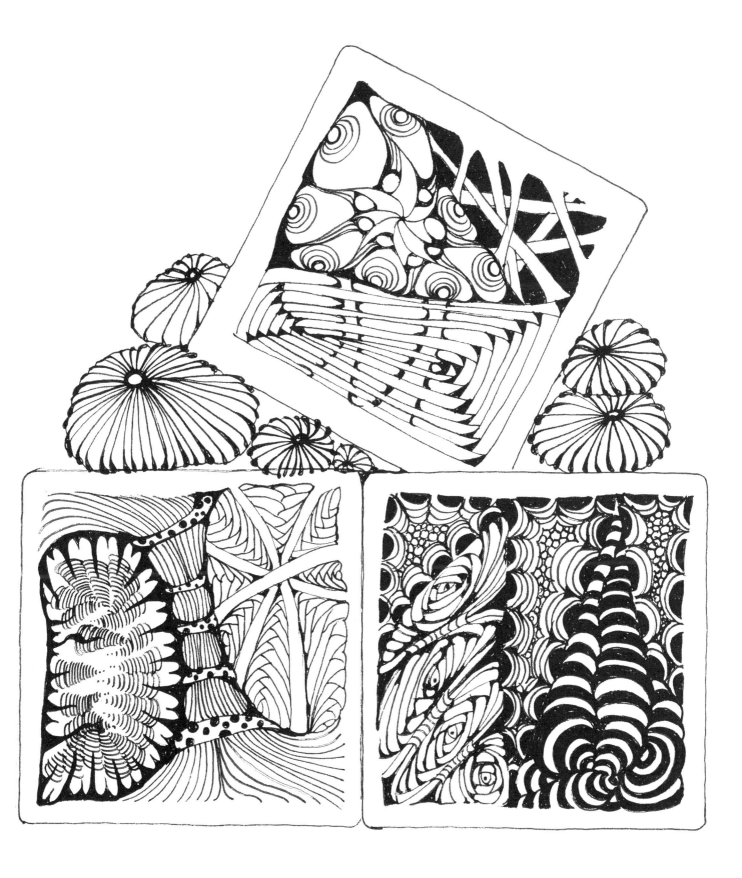

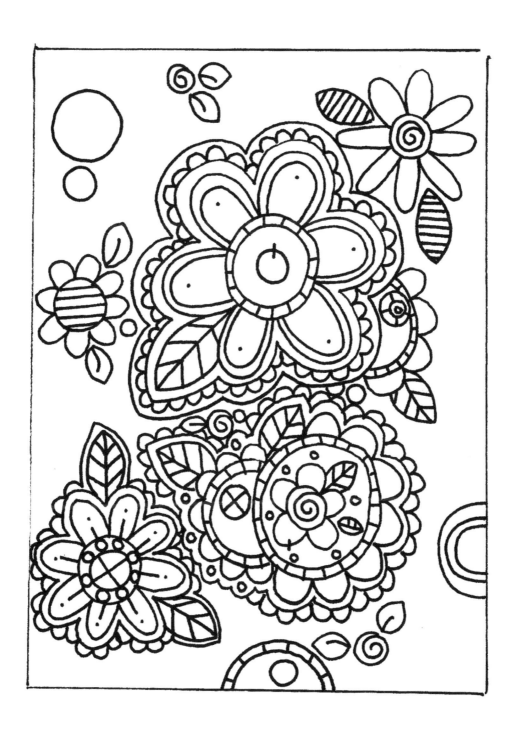

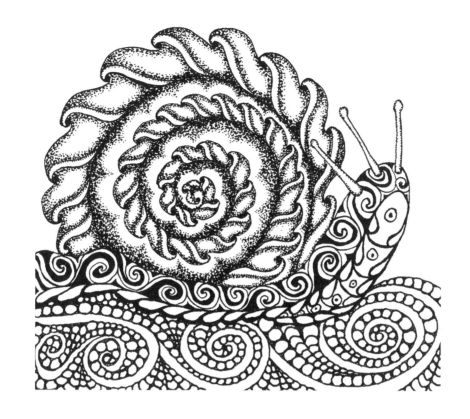

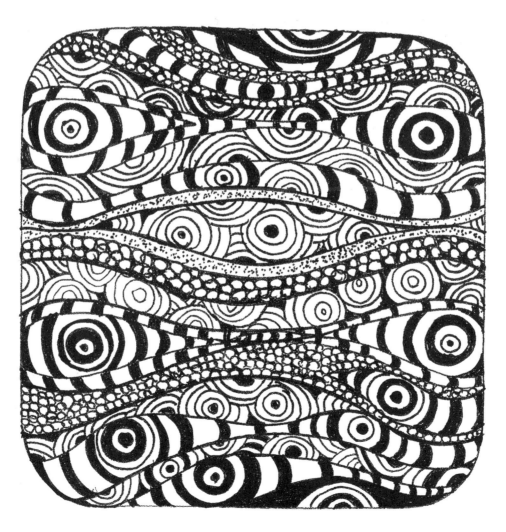

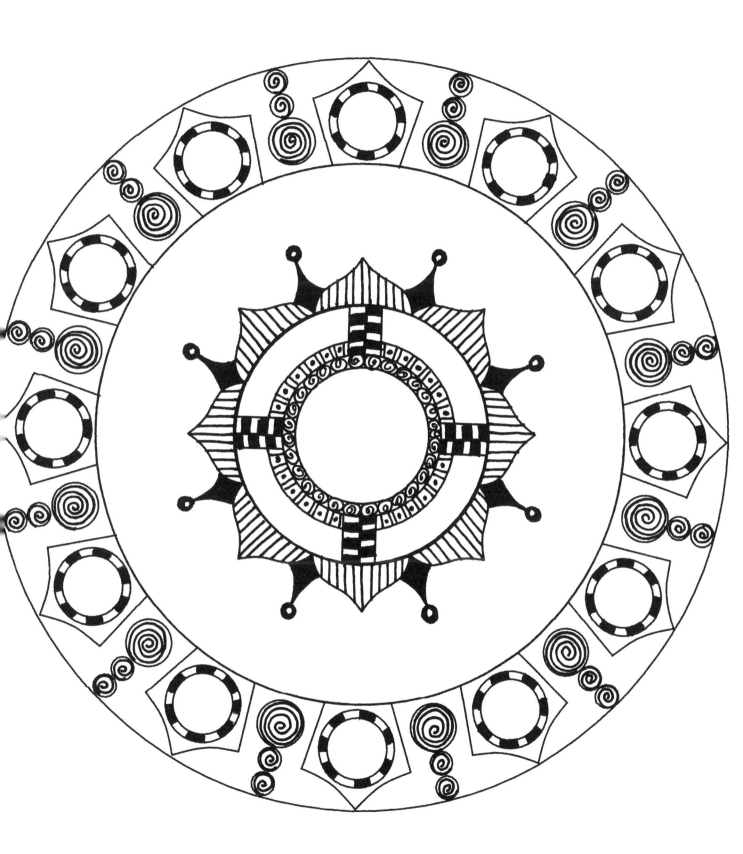

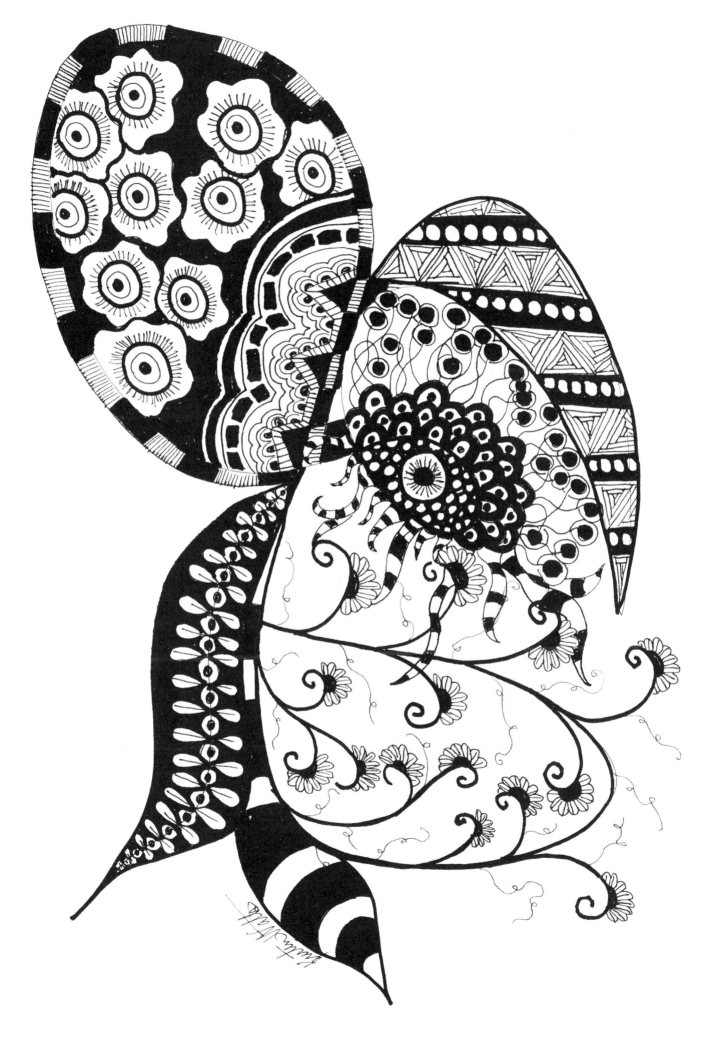

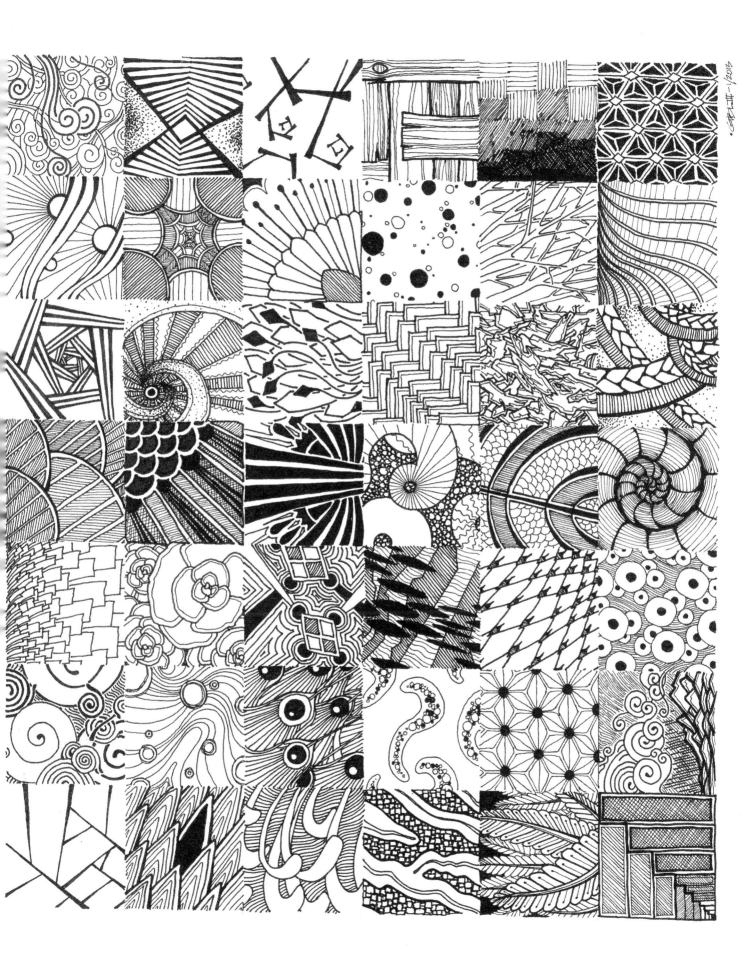

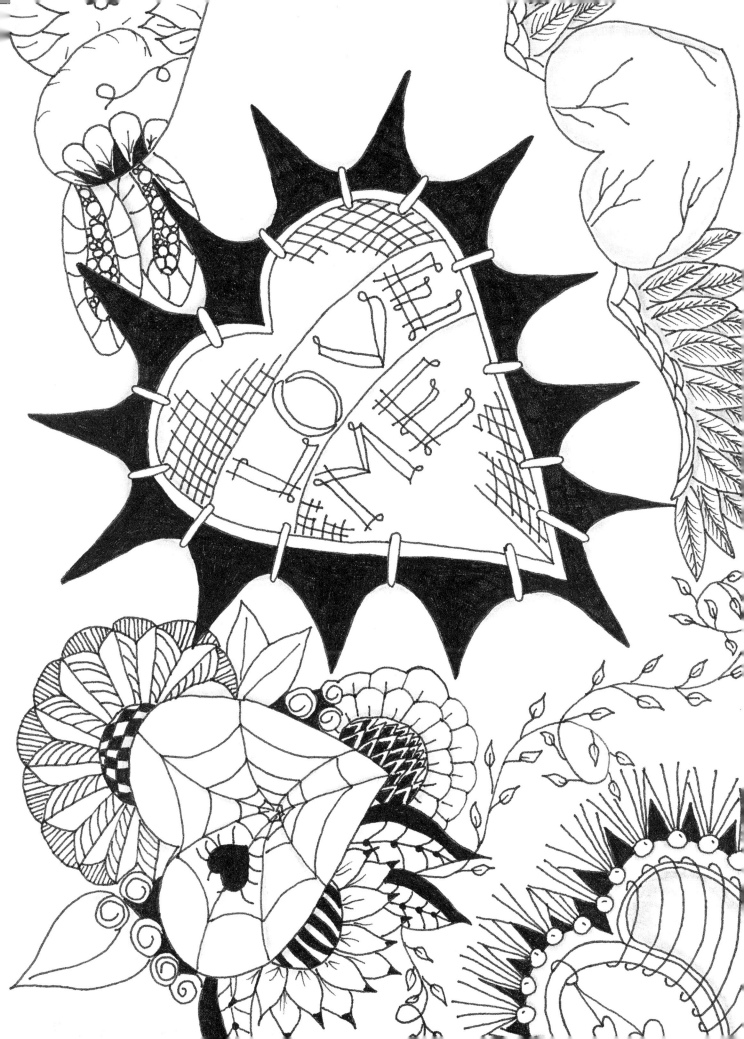

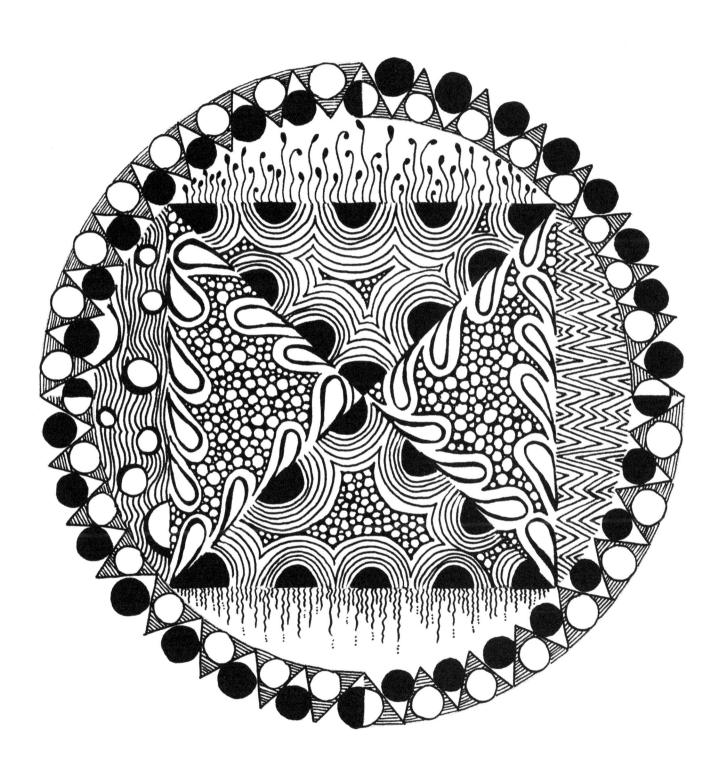

The art in
the zen doodle coloring book
was originally published in these books:

PREVIOUS PAGE:
Tiramisoo zendala
KASS HALL
(FROM THE ZENTANGLE® UNTANGLED WORKBOOK)
includes the following Tangle patterns: Tiramisoo, nip, fescu, msst, static, crescent moon, ennies

special thanks to our contributing artists:

Kass Hall
KASSHALL.COM

Trish Reinhart
REINSTONZ.COM

Genevieve Crabe, CZT
AMARYLLISCREATIONS.COM

Nancy Miller Pinke, CZT
PINKE.FREEYELLOW.COM

Stephanie Ackerman
HOMEGROWNI@ATT.NET
HOMEGROWNHOSPITALITY.TYPEPAD.COM

Sue Brassel
CRAWFORDSVILLE, IN
SUE@SUEBRASSEL.COM
SUEBRASSEL.COM
ATHENS OF INDIANA ARTS STUDIOS AND GALLERY

Brenda Campbell
BRENDA@ANGELWHISPERSART.COM
ANGELWHISPERSART.COM

Lisa Chin
SAQA, USDG
SOMETHINGLISA@HOTMAIL.COM
SOMETHINGCLEVERABOUTNOTHING.BLOGSPOT.COM

Susan Cirigliano, CZT 9
CIRART@VERIZON.NET

Cathy Cusson
716 PYRON LANE
EAST RIDGE, TN 37412
CATHYCUSSON54@GMAIL.COM

June Crawford
ACREATIVEDREAMER@GMAIL.COM
ACREATIVEDREAMER.BLOGSPOT.COM

Ruth Dailey
BAY AREA BOOKS ARTS, MILLIANDE BOOKMAKING
GROUP, REGIONAL ART ASSOC.
(831) 247-3335
RODAILEY@YAHOO.COM
SCOTTS VALLEY ARTISAN/ART SANTA CRUZ
FACEBOOK.COM/INSPIREDAILEY
FINEARTAMERICA.COM/PROFILES/RUTH-DAILEY
ETSY.COM/YOUR/SHOPS/INSPIREDAILEY

Melodie Dowell
WSI, HOOSIER SALON, LOGANSPORT
ART ASSOC.

1263 E. COUNTY ROAD 75N
LOGANSPORT, IN 46947
(574) 732-1375
VICMELD@COMCAST.NET

Christine Alane Farmer
CHRISTINE.ALANE@ATT.NET
NESTFEATHERSANDTWINE.BLOGSPOT.COM

Kathie Gadd
LAVENDERCHALET@GMAIL.COM
LAVENDERCHALET.COM

Victoria Schultz Grundy
VICABBOLL@GMAIL.COM

Sally Harrison
SHROPSHIRE, UK
07446 764884
MOLLYMEGUK@GMAIL.COM
ARTYMOLLYMEG.CO.UK

Eden M. Hunt
ELECTRONMOM2000@GMAIL.COM
CUTNITIP.BLOGSPOT.COM

Heather M. Jackson
JACKSH3@AUBURN.EDU
FLICKR.COM/HEATHERJACKSON3

Barbara Kaiser
BKAISERSTUDIO@GMAIL.COM

Dr. Lynnita K. Knoch
AQS, AQG, ART PLAYERS
MIXED-MEDIA GROUP
(480) 529-8086
LYNNKNOCHI961@GMAIL.COM
LYNNITAKNOCH.BLOGSPOT.COM

Catherine Langsdorf
HENDERSONVILLE, NC 28791
(828) 697-3336
C_LANGSDORF@YAHOO.COM
ALPHABEETANGLES.BLOGSPOT.COM
FACEBOOK.COM/CALLIGRAPHYLVL

G. Blaine Liddick III
THE DORIS BARTON COMMUNITY CULTURAL CENTER
1010 NW 36 AVENUE
GAINESVILLE, FL 32609
352.870.4991
LIDDICKGB@GMAIL.COM
LIDDICKGB@YAHOO.COM

contributors, continued:

Kathleen McArthur

Deborah A. Pacé
DPAVCREATIONS@GMAIL.COM
DPAVCREATIONS.BLOGSPOT.COM
AARTVARKCRE8TIONS.COM

Kim Pay
GOOD SHEPHERD ART STUDIO
CALGARY, ALBERTA, CANADA
POWDERMAMA@GMAIL.COM
POWDERMAMA.BLOGSPOT.COM

Jane Reiter
2211 HILLTOP DRIVE
LANSING, MI 48917-8631
(517) 327-0938
JANEREITER@SBCGLOBAL.NET
TANGLEWRANGLER.WORDPRESS.COM
RETREADART.BLOGSPOT.COM

Kim Reitsma
STRATHROY, ONTARIO, CANADA

Nancy V. Revelle
NAN@NANSAIDH.US
NANSAIDH.US

Valentine Werchanowskyj Roché
CHANGEWAY@EARTHLINK.NET
CHANGEWAYSROCHE.WEEBLY.COM

Annie Sanderson
FINE ART AMERICA
MYGREEKGIRL@AOL.COM

Barbara Simon Sartain
ROCKY CROSS STUDIO
ROCKYCROSSSTUDIO@GMAIL.COM
ROCKYCROSSSTUDIO.BLOGSPOT.COM

Olga Schrichte

Martha Slavin
FRIENDS OF CALLIGRAPHY, SAN FRANCISCO, CA
NATURE PRINTING SOCIETY
COLLAGE ARTISTS OF AMERICA
SLAVINFAMILY@HOTMAIL.COM
MARTHASLAVIN.BLOGSPOT.COM

Judith E. Strom

Kristen Watts
ARTPLAYTODAY@GMAIL.COM
ARTPLAYTODAY.COM
CRAZY LADY GALLERY AND GIFTS
PORT ORCHARD, WA

Vanessa Wieland

Jay Worling
JAY.WORLING@GMAIL.COM
JWORLING.COM

about the editor

Kristy Conlin is managing editor for F+W Media's North Light art community. She has a degree in journalism and a minor in Spanish (which has imbued her with a serious crush on Mexican and South American art). Kristy has been surrounded her entire life by art and craftiness—her mom, dad, grandmother and brother are seriously artsy/crafty—and there is probably no medium she hasn't at least tried.

Encouraged and inspired by the authors she works with, Kristy currently dabbles in art journaling, acrylic painting and encaustic painting and is ready to tackle urban sketching. She is a convert to the wabi-sabi philosophy of honoring the aged, the humble and the oftentimes overlooked. When she's not at work, Kristy can usually be found reading, running, watching movies or writing. She lives in Cincinnati, Ohio, with her husband, dog and two cats.

a content + ecommerce company

other fine North Light (IMPACT) products are available from your local bookstore, art supply store or online supplier. Visit our website at fwmedia.com.

ISBN: 978-1-4403-4282-0

19 18 17 16 15 10 9 8 7 6

Distributed in Canada by Fraser Direct
100 Armstrong Avenue
Georgetown, ON, Canada L7G 5S4
Tel: (905) 877-4411

Distributed in the U.K. and Europe
by F&W Media International, LTD
Brunel House, Forde Close, Newton Abbot, TQ12 4PU, UK
Tel: (+44) 1626 323200, Fax: (+44) 1626 323319
Email: enquiries@fwmedia.com

Distributed in Australia by Capricorn Link
P.O. Box 704, S. Windsor NSW, 2756 Australia
Tel: (02) 4560-1600; Fax: (02) 4577 5288
Email: books@capricornlink.com.au

Edited by KRISTY CONLIN
Designed by HANNAH BAILEY
Production coordinated by JENNIFER BASS

A Note from the Editors

While this is a book about doodling, many of the contributors were inspired by the Zentangle® method of drawing. You can find out more about Zentangle® at the Zentangle® website.

About Zentangle®:

The name "Zentangle" is a registered trademark of Zentangle Inc. The red square logo, the terms "Anything is possible one stroke at a time," "Zentomology" and "Certified Zentangle Teacher (CZT)" are registered trademarks of Zentangle Inc. It is essential that before writing, blogging or creating Zentangle® Inspired Art for publication or sale that you refer to the legal page of the Zentangle® website. www.zentangle.com

zentangle®
www.zentangle.com

The Zentangle® method is a way of creating beautiful images from structured patterns. It is fun and relaxing. Almost anyone can use it to create beautiful images. Founded by Rick Roberts and Maria Thomas, the Zentangle® method helps increase focus and creativity, provides artistic satisfaction along with an increased sense of personal well-being and is enjoyed all over this world across a wide range of skills, interests and ages. For more information, please visit the Zentangle® website.